G000113529

Published by City Point Press 2022

Copyright © Human Touch Media
www.humantouchmedia.com
www.faceswelove.com

All rights reserved. No part of his book may be reprinted or reproduced or utilized in any form or by any electronic, mechanical, or other means, now known or hereafter invented, including photocopying and recording, or in any information storage or retrieval system without permission in writing from the publisher.

Hardcover ISBN 978-1-947951-44-0
ebook ISBN 978-1-947951-45-7

Compiled by Derek Muhs and Marisa Tarin

Edited by Lydia Delaney
Designed by Natasha Rees and Ugly Dog Digital
Printed by ODDI Sales

Manufactured in Bosnia and Herzegovina

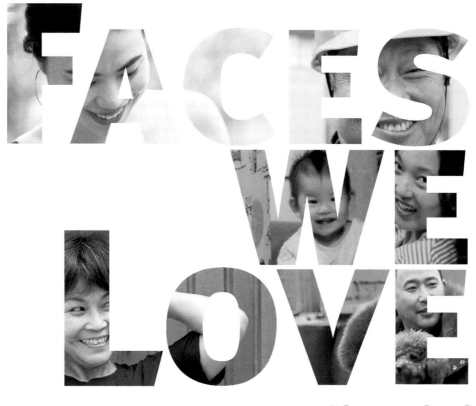

FACES WE LOVE

Shanghai

AUTHORS & CURATORS

Derek
Muhs

Marisa
Tarin

"Shanghai, once visited
... never left"

Foreword

"The function of the artist is to disturb."

These are the words of my cousin, Dr. Norman Bethune. While he is known worldwide as one of the most influential doctors of all time, Norman Bethune was also an inventor, a philanthropist, an author, a painter, and a poet. A true artist. Did he "disturb," or "disrupt?" Disruptive minds are minds that effect change and have a positive view of change, enjoying the process. They are early adaptors and challenge what is considered normal. When I think back on my cousin's incredible life in China, without a doubt, he did disrupt. And in such a positive way, including his humanitarian work in China, which ultimately cost him his life in 1939.

Bethune's journey to China, and his love for people is part of the reason I moved to China. When I made my first journey there, over 15 years ago, I arrived, as most visitors to any foreign land do, with a preconceived idea of what I would see and experience. However, there were many surprises. Most surprises were very pleasant, not the least of which was discovering how much, as individuals, we have in common. It is very easy to default to see the negative characteristics in a culture, language, and place different from our own. But it is far more rewarding to look through that to find where we are similar and what we can learn.

This has been the practice of the curators and contributors of this collection. I have followed their work for many years and have personally witnessed their affection for Shanghai and their passion for capturing the humanness that we all share. The *Faces We Love* collection touches my heart, and is particularly refreshing because it gives us a view of Shanghai that is not just the typical glamor and glitz we often see featured in glossy magazines. This collection tells the story of everyday people doing fascinating things. Each photo tells their unique story.

What is disruptive about the photographer capturing people through his lens, or the casual observer watching strangers on the street go about their daily business? The disruption is in our preconceived ideas about people, in our home territory, or abroad. Can I see myself in the elderly woman dancing freely in the park; the street vendor proudly offering his perfected dumplings; the little girl laughing at strangers from the back of a scooter? I can. We all can. This very slight disruption can help serve to open our minds, break down prejudices and build friendships.

This book is not a deep sociological statement, but rather a brief glimpse into the patterns and the pleasant disorder that are the texture of one of the most populous cities in the world. So sit back, turn the pages slowly as you take your own journey through the city, and look for your own self in some of the faces we love, in Shanghai.

Sarah Bethune-Kelly
Humanitarian and Writer

AUTHOR'S NOTES

"Beautiful things don't ask for attention." *

Shanghai - What is it?

In preparing to release this collection we would ask anyone who had a connection to the city, "What comes to your mind when you hear SHANGHAI?" Some of the reactions were: *"high energy"*; *"the Pearl Tower"*; *"Yao Ming"*; *"a contrast of old and new"*; *"Disneyland"*; and finally, *"I just love all those really old buildings on the waterfront, what do you call that waterfront again?"* Ok, that last one was my mother.

From historical properties to iconic skyscrapers, the architecture of Shanghai old and new, without question, commands attention globally. It would be too easy to assume that these are the images that define Shanghai. Isn't it interesting that we can be quick to honor concrete and steel, but not people? Sometimes, the magnificence of the architecture can overshadow the beauty of what we personally consider Shanghai's true treasure - its people. The men, women, and children who really make this city work; they are its heartbeat. Shanghai is a melting pot of diversity, bringing together people from all across the country, contributing to a colorful blend of cultural heritage that makes life there so interesting. *Faces We Love* celebrates these people. It tells their story.

My own family's journey, which began in 2007, introduced us to a city that we thought we knew through several trips over the years, but in truth we had barely scratched its surface. We found ourselves living in a city where we didn't speak the language or fully understand the culture. We went from being total strangers in Shanghai to, ultimately through the generosity and patience of our local neighbors, being welcomed into the family. We have attempted to capture that journey and those moments in this collection.

Shanghai is one of the most photographed cities in the world. Like most Shanghai fans we have had our turn standing on the Bund, looking over the river trying to capture that postcard skyline selfie, with the Pearl Tower perfectly positioned. Full disclosure: I'm still working on that shot. In the early days while hosting some visitors, we were huddling together desperately trying to get that perfect Bund angle without the double chins, when I noticed a mom with two young kids. She had one child strapped to her back, and the other pulling on her sleeve as she was trying to sell souvenirs on a Sunday night. As I was watching her determination, her smile, I wondered, What's her story? It was as if my eyes adjusted from the sparkle of the skyline and brought people from the shadows into focus. There was a middle-aged gentleman, with a cute dimple and wiry goatee, quietly and methodically pruning the manicured flowers lining the Bund walkway, working away as thousands of visitors, both local and foreign, bustled around him - What was his story? That moment was one of many over the years that gave me the opportunity to get past the WOW of the buildings and properly see faces. Faces of people who are anything but ordinary, they are the true backbone of Shanghai and all have a story to tell. Experiences like that uncovered the true beauty of Shanghai, one face at a time, and defined the principles of the collection you will see in this book. We have tried to capture honest, unfiltered, human moments that reveal untold stories.

*From the 2013 film *The Secret Life of Walter Mitty*

I really love classic jazz and the big band era, so the reputation of Shanghai as a cool, cosmopolitan city with deep roots in vintage jazz always interested me. Looking back at other musical hotspots such as New York and London, Shanghai, with its ensemble of home-grown talent, became the Asian hub of toe-tappin', finger-snappin' jazz. Those musical roots have been maintained over generations. It's exciting to find yourself in a city where it could be 1938 or 2008, and you still hear the sounds of Glen Miller, Count Basie, and Fats Waller. An entire new generation is swinging to the classics of a heyday era that is very much alive. Shanghai has had a rhythm to its progress and development like nowhere else in the world, and yet somehow its history keeps to the same steady beat.

I really miss cycling through the tree-lined streets of Shanghai. I was able to gain a much-needed different perspective while pedaling, it was therapeutic and calming. Life seemed to slow down when I was on my bike: I was able to observe moments and people, and actually appreciate what I was part of.

One day I was in the former French concession on Changle Road when I saw a Penny-Farthing bicycle outside one of the old lane houses. My appreciation of vintage bikes stopped me in my tracks, and I was curious to know who owned it. It was a reconditioned bike, with the huge front wheel and much smaller back wheel, the kind you would see in the late 1800s. This bike is incredibly difficult to mount or to actually ride and, of course, it is almost impossible to stop safely. Clearly, I had no choice but to buy it. I peeked inside as the front door was slightly open and saw a wonderful scene. Bikes everywhere. Mom was in the corner preparing soup dumplings, dad in the back covered in grease. Home-made dumplings were sizzling to perfection with whispers of garlic and ginger particles floating directly into my nostrils. I watched the family excited to dig in, and there was me desperately wondering, *"How can I get in on that food action? Oh, and buy a bike I can't ride!"* This was truly a family-run business and it pulled me right in. Emerging from this scene of beautiful chaos came Danny, a good-looking young man who greeted me with a smile. Within a very short period of time he discovered my Chinese was horrible; but we bonded with smiles and our shared love for vintage bikes, and of course his mothers' home-made dumplings, delicious with each delicate bite. That day I found myself as the new owner of the Penny-Farthing bike. A highly impractical purchase, but a purchase I will never regret. That meeting and impulse shopping spree was the start of a long relationship with Danny's beautiful family.

In time, Danny's family business grew, and they moved to a new high street location on Julu Lu, a very trendy street in Shanghai. The bike shop functioned for quite a while without a name, just on a family reputation of trust, until one day, while sitting on the sidewalk on tiny wooden stools discussing the purpose of life we randomly said, *"How about '2 wheels'?"* It stuck, and the business was named. *2 wheels* has now become the seal on thousands of bikes whizzing around the city streets. I found it interesting to see such an enterprising young person running a business around one of the oldest forms of transport: the pedal bike. I loved the simplicity, the energy of his family-run business, and the sense of community you would feel the moment you walked into their shop. Danny's mother worked at the shop all hours, yet this incredible woman would manage the business, repair, cook, and be a new grandmother all at the same time. Her permanent smile despite the stresses of life made a terrific impact on everyone she met. We captured her beautiful face one day in front of a classic red Shanghai door and as you look through our book you will see her, Danny, his beautiful wife, and their adorable baby with Grandad. Faces we really miss and faces we really love.

The knife-sharpening guy had no mobile phone. My wife Marisa, also one of the photographers contributing to this collection, could locate him only through our neighbors. He was sitting in

the street surrounded by knives, with a distressed sharpening block. The first words they shared were merely a cautious nod from him as Marisa persevered in her broken Mandarin. The nod turned to a smirk, this was huge progress! His calloused fingers worked away and as they slid over the edge of the knife she was just mesmerized. On the second visit, after several attempts to find her mystery man, Marisa was greeted with a grin. Third visit, a full smile. Hurray! They were now friends and it was the start of a 10-year relationship. Marisa actually choked up when she saw a photograph submitted for this collection that captured our dear knife friend and included him in this collection. How random. A face we miss; a face we love.

I remember when our 80-year-old neighbor was playing *Peking Opera*. Marisa went to sit with him and, although her ears were not accustomed to this unique sound, she was fascinated by how her new companion's eyes sparkled with joy as he explained it to his captive audience. His wife looked on with caution, watching this new foreign neighbor. "*Nakuni*" (Shanghainese for foreigner), we would hear her repeat. Looking back, I can only imagine what she must have been wondering: Who is this foreign woman? Why is she talking to my husband about *Peking Opera*? Marisa felt that, as the newcomer, she needed to make the effort to gain their trust. Interestingly, as the months passed, that trust began to grow through simple things, such as a shared love for food. It was an easy way to bridge the cultural divide. Marisa would try their dumplings; they would have a slice of home-made pizza. A taste, a smile, a friendship. That bond became very precious last year when tragically her opera tutor suddenly died. She could hear his wife crying through the night, devastated by the loss of her life partner. When Marisa went to see her the next day they hugged and cried together. No words were needed. She is a friend to this day.

"*Beautiful things don't ask for attention*" resonated with us because we felt it was something we saw every day, and those are the moments we hope you enjoy as you flip through the pages of this book.

There are no words in any language to truly describe the moments we shared with our local friends in Shanghai. Looking back over the many years we were welcomed into their neighborhood, every experience we had was enhanced by the kindness and love shown to us. What a journey! There are countless untold stories from our time in Shanghai, but we hope this collection of photographs brings some of them to life, breaking through language barriers, capturing honesty, and giving a true-to-life glimpse of this fabulous city that has given us so much.

The photographs found in *Faces We Love* allows us to visually visit a city we love and a city we miss, and it is the desire of all who worked on this collection that you can relax and enjoy this journey with us. I was trying to think of some big dramatic description to finish on but, honestly, I can't express it any better than the way one of our photographers did when he said: "*The Faces We Love collection has made me fall in love with Shanghai all over again.*"

Derek Muhs, December 2020

Dedicated to the
people of Shanghai

谨此献给
上海人民

This woman's work

她的工作

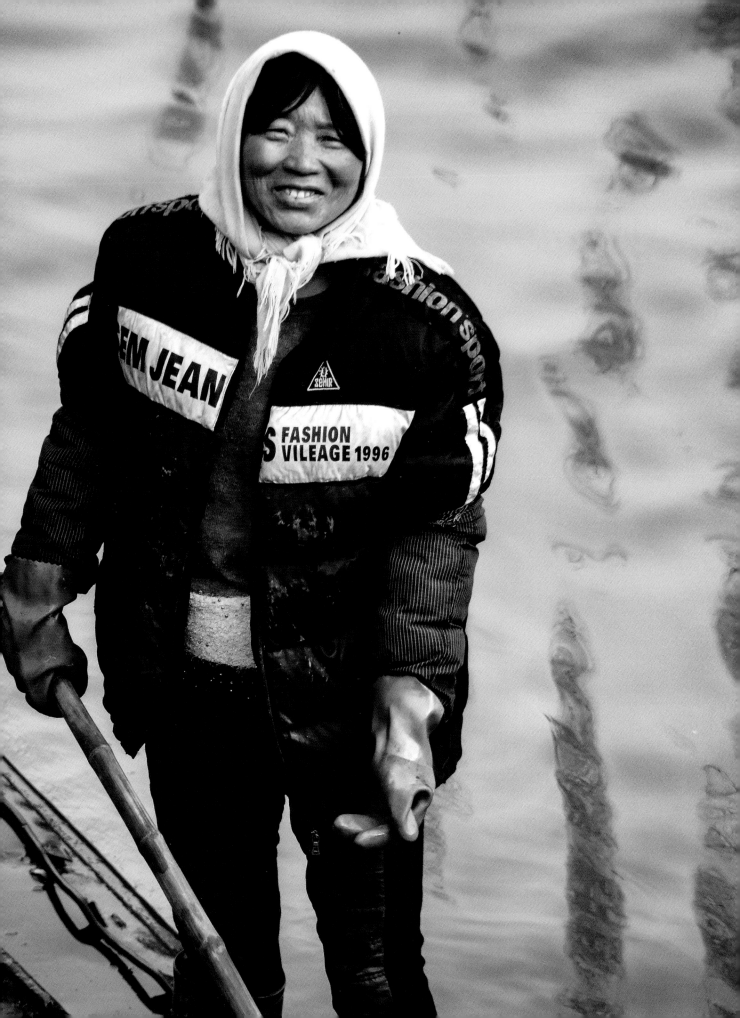

Ship's captain

我是船长

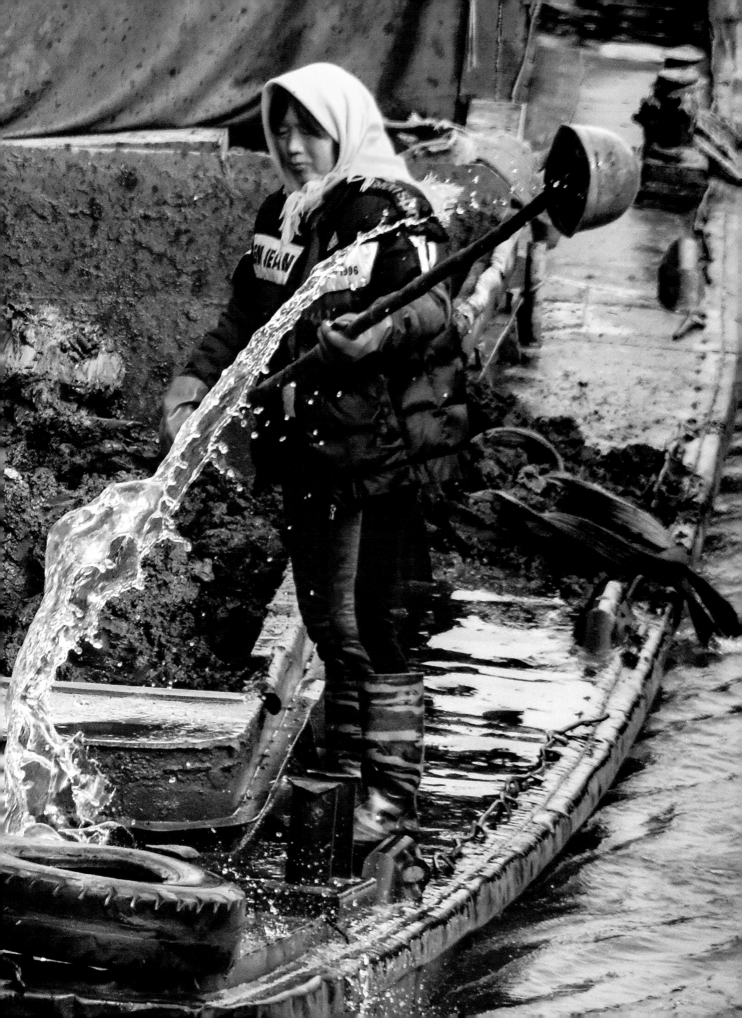

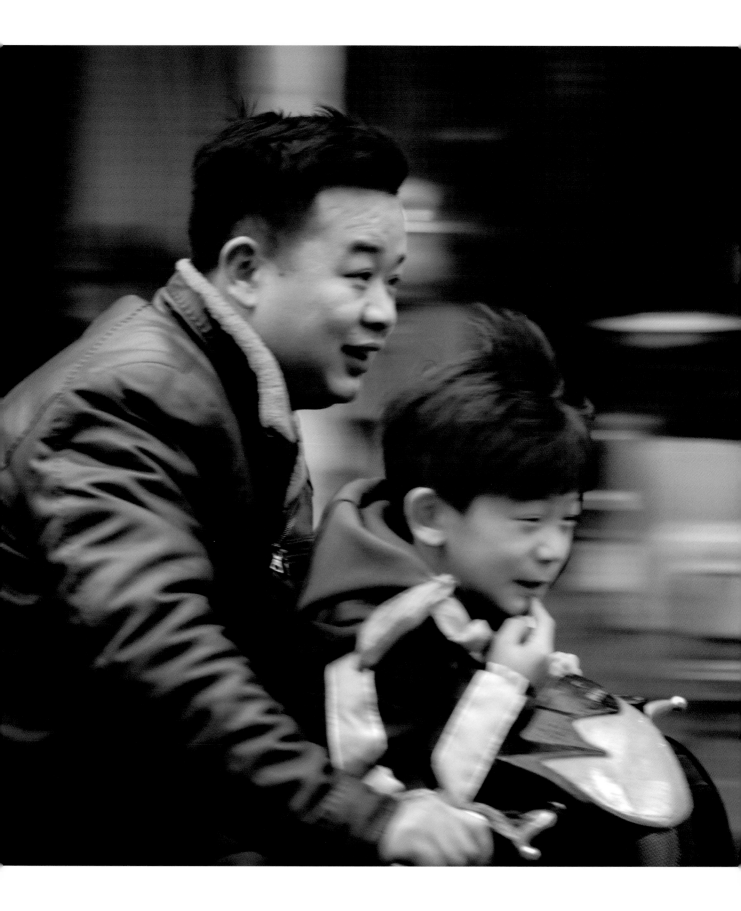

Faster, Dad!

爸爸，加速!

笑脸

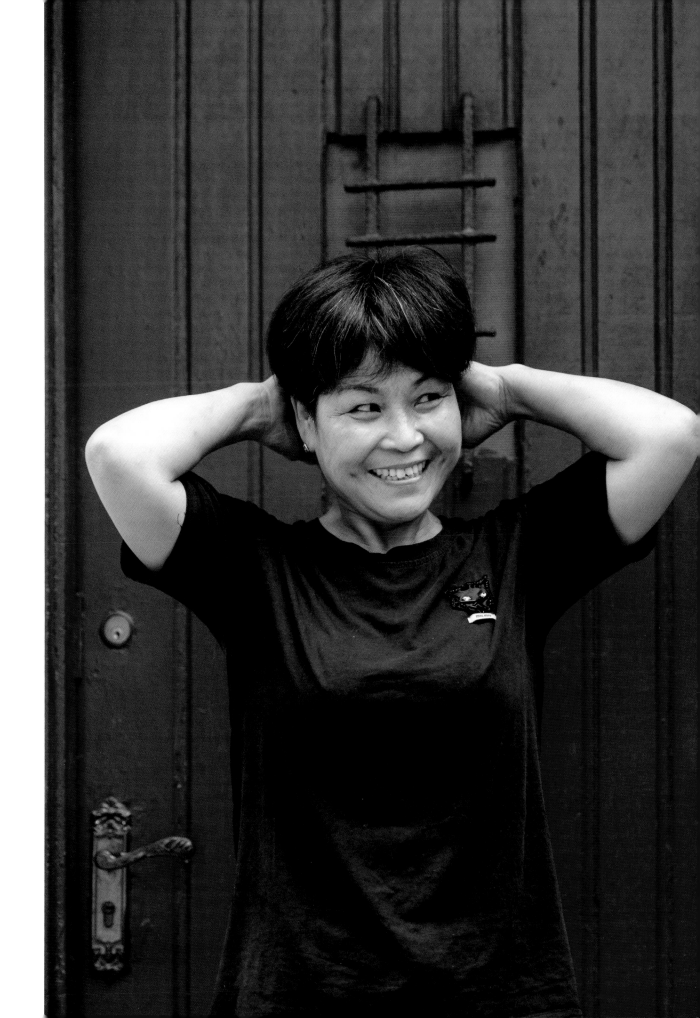

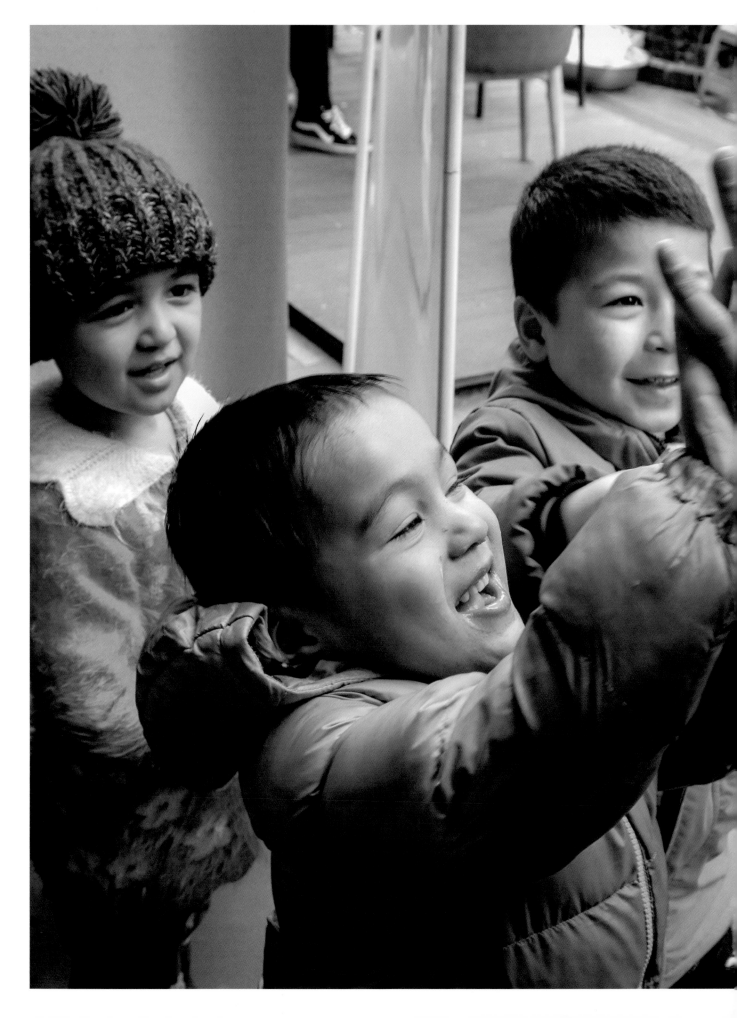

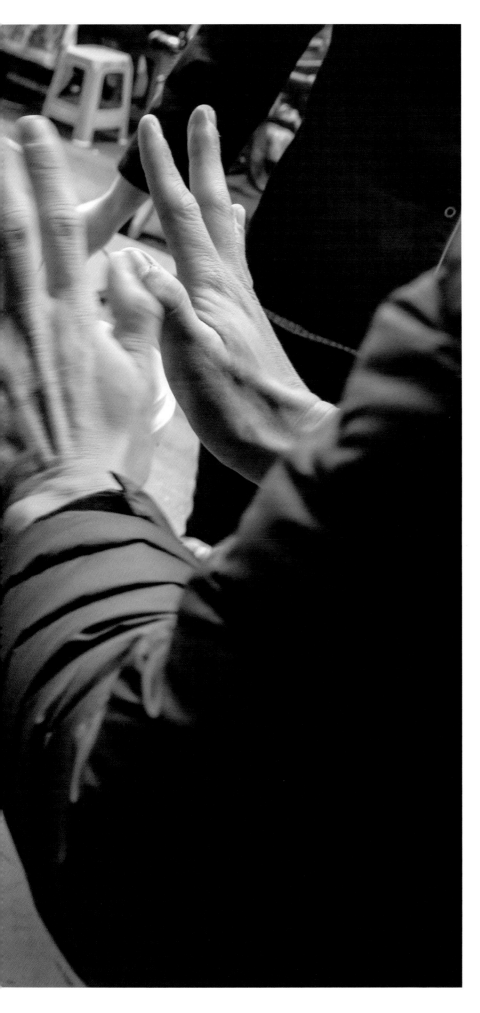

小手拍大手

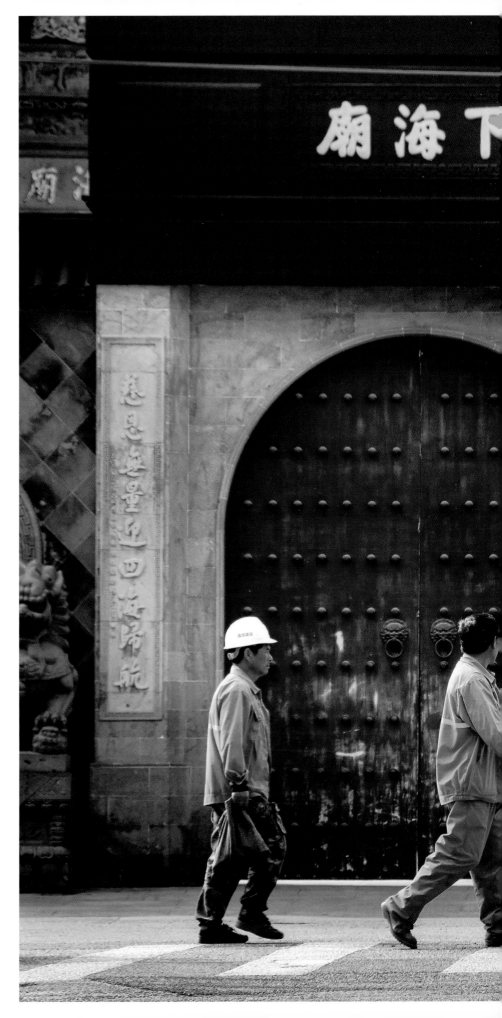

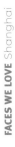

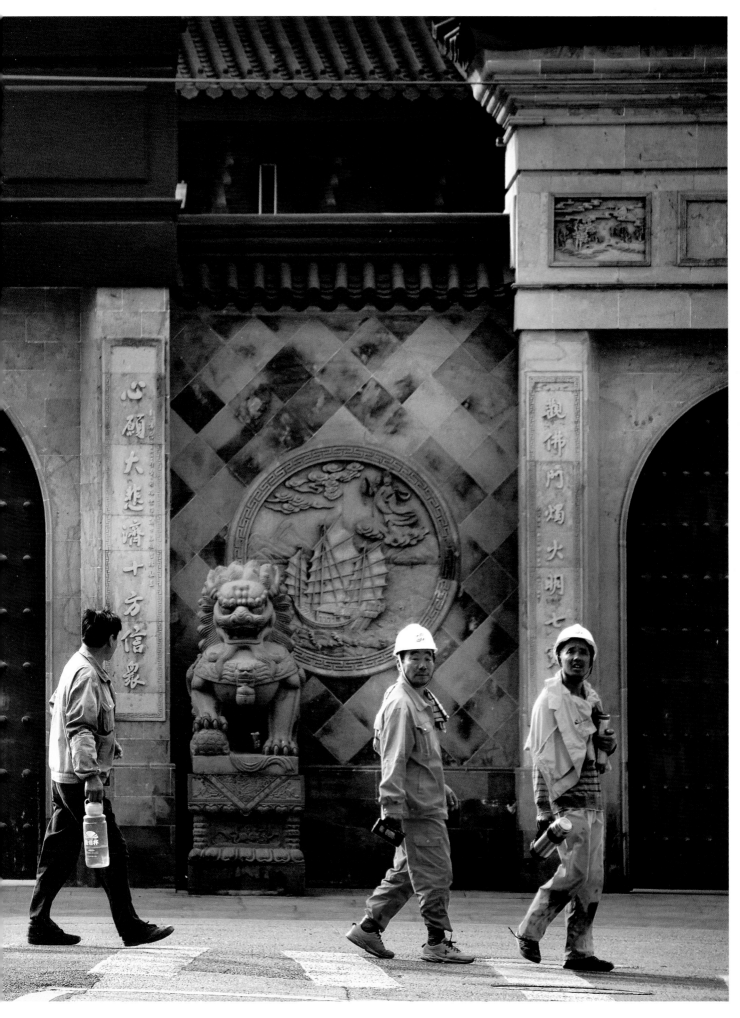

If the world was
blind
how many people
would you impress?

如果世人都是
眼盲的
你如何让人
眼亮？

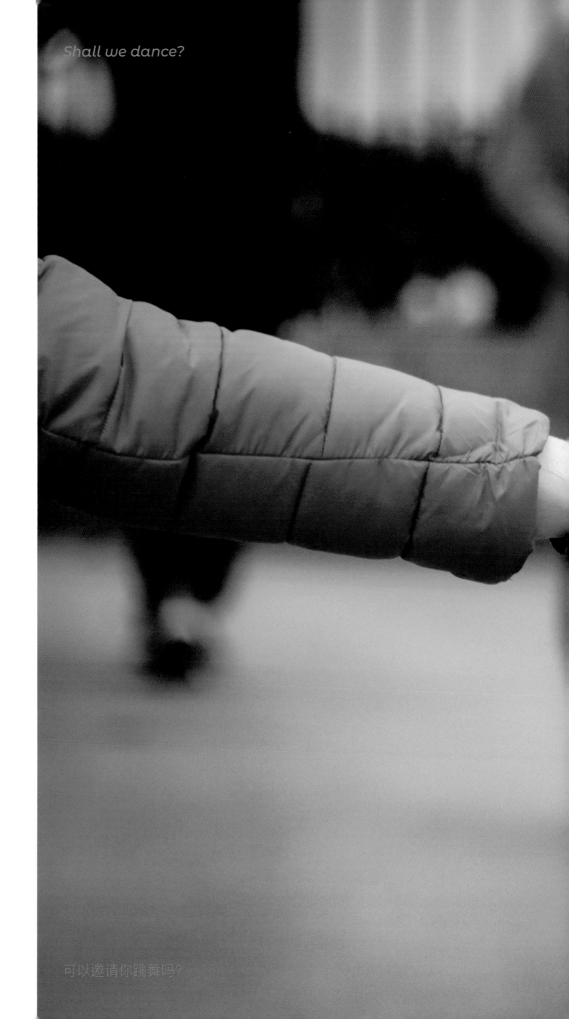

Shall we dance?

可以邀请你跳舞吗?

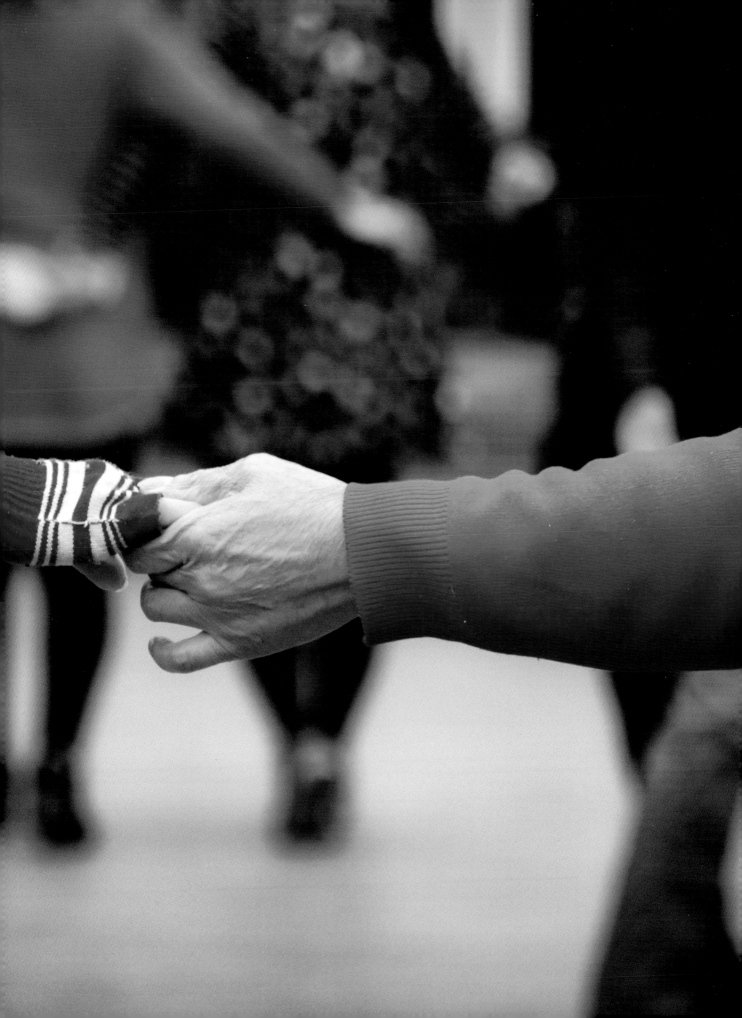

Tuning up

调音

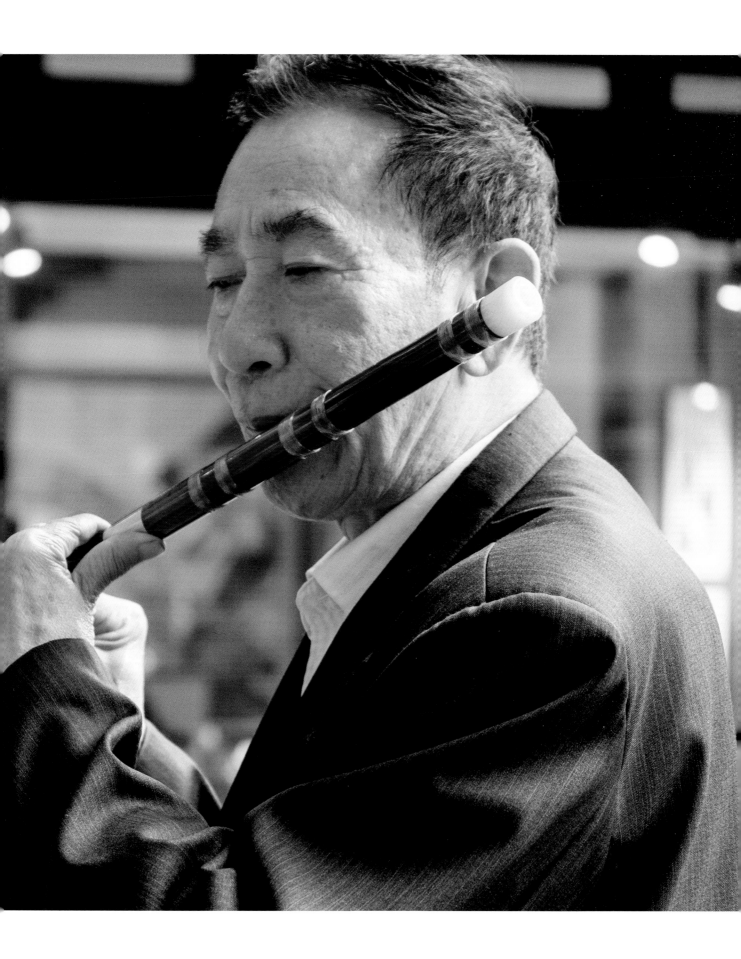

The glance

瞬间

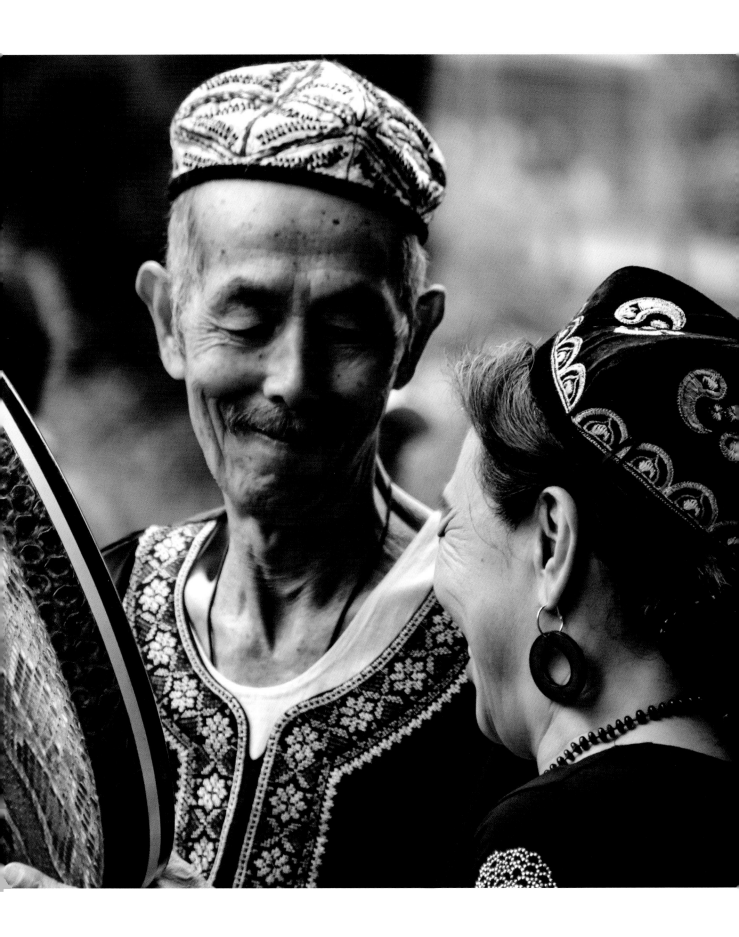

My baby girl

我的宝贝女儿

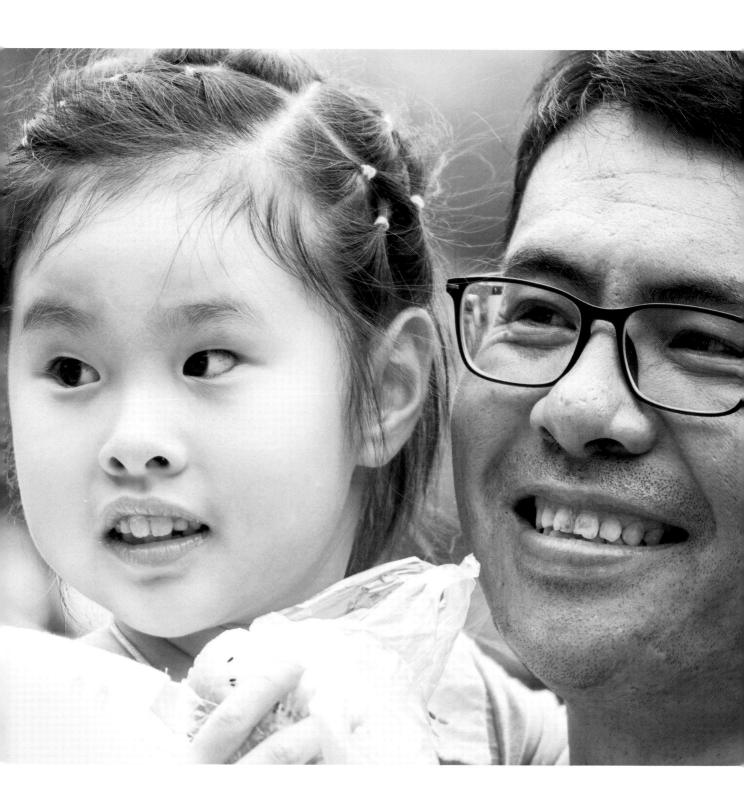

我酷吧，不要恨我哦

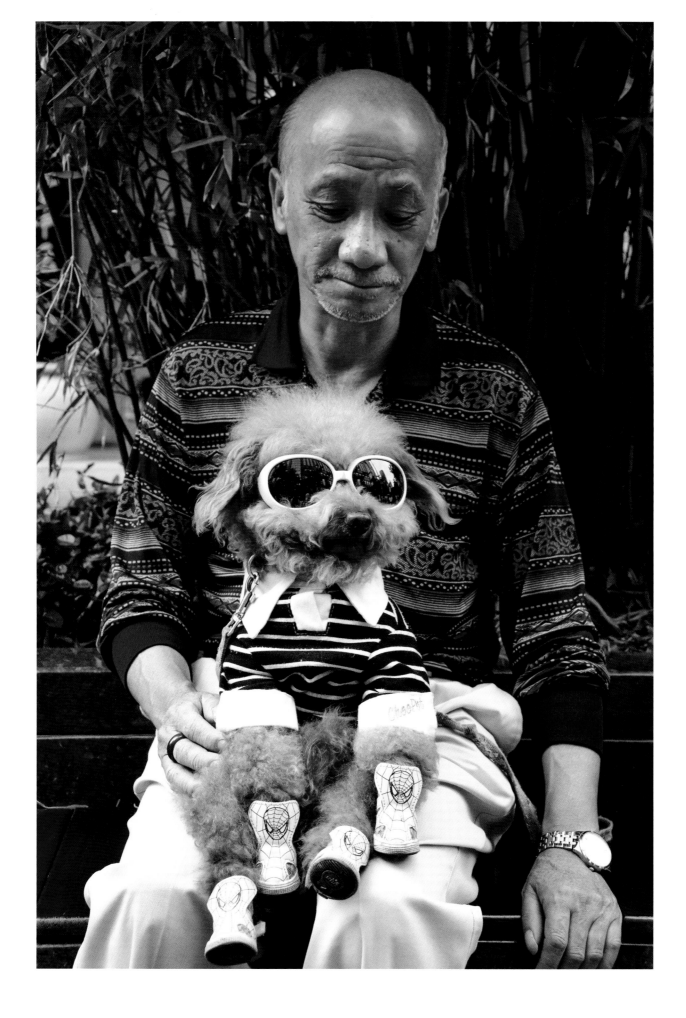

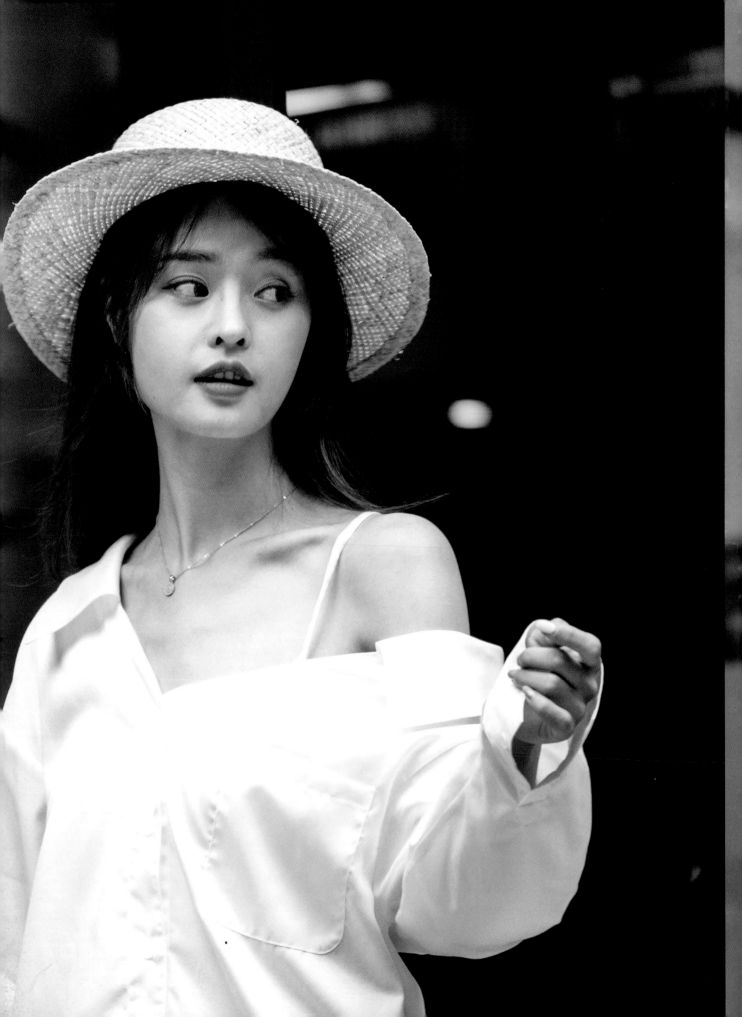

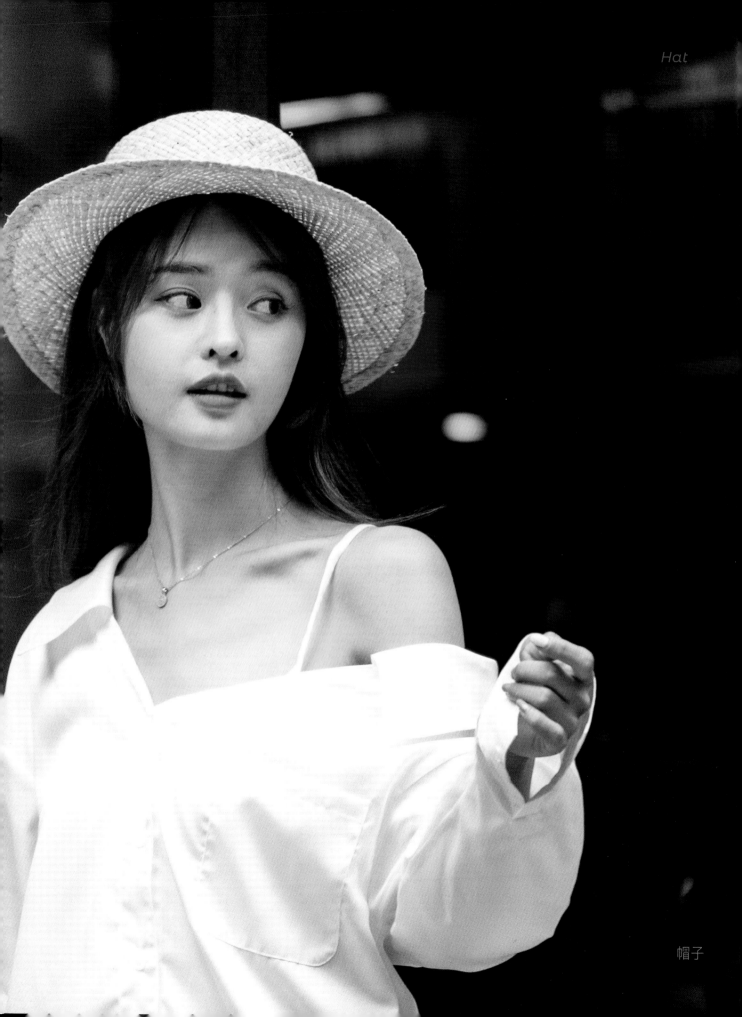

Hat

帽子

皱纹应该只是
微笑留下的印记
马克吐温

Wrinkles
merely mark
where smiles
have been

Mark Twain

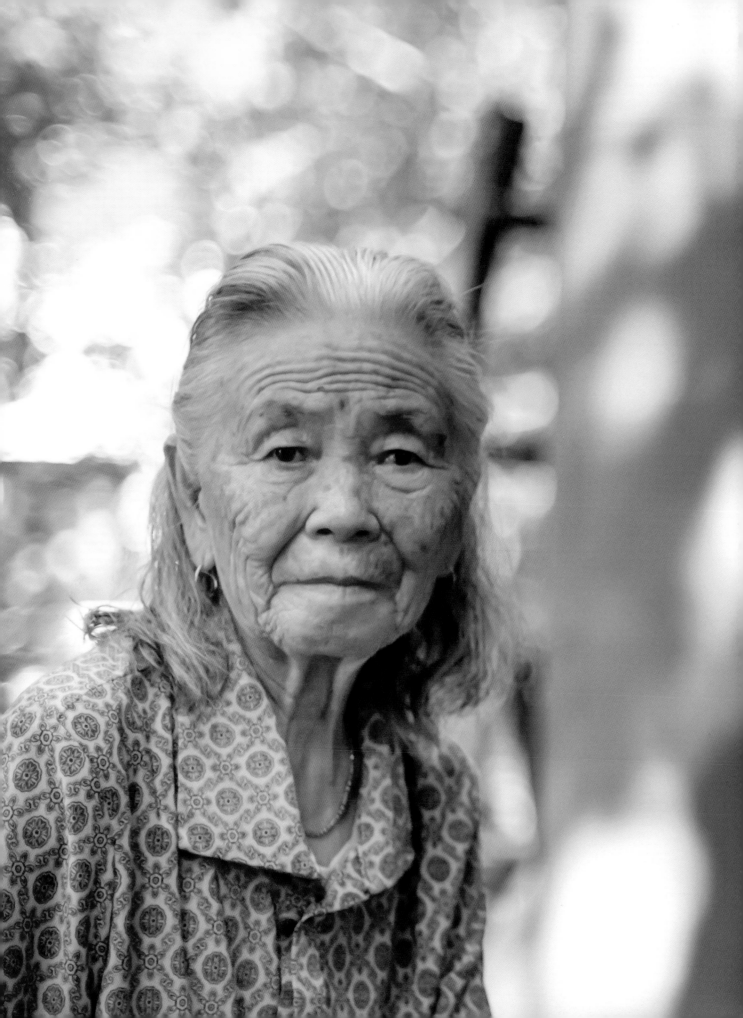

Silver crown of beauty

银发就是华美的冠冕

Groove on

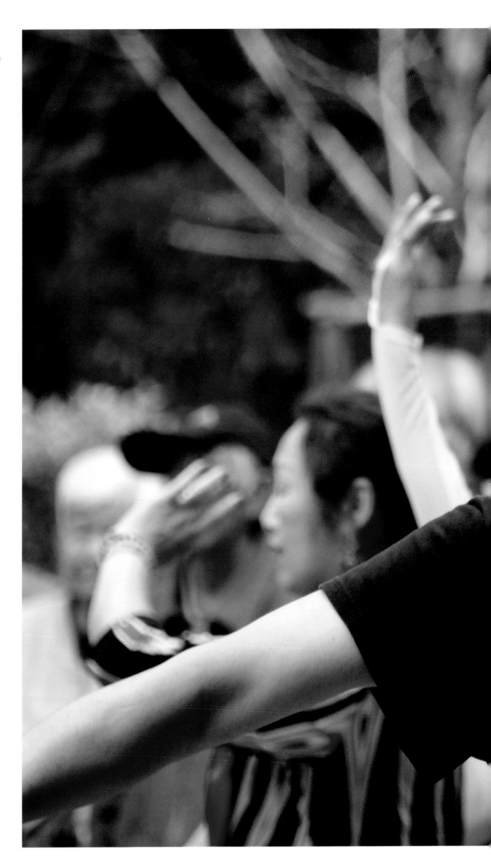

嗨起来

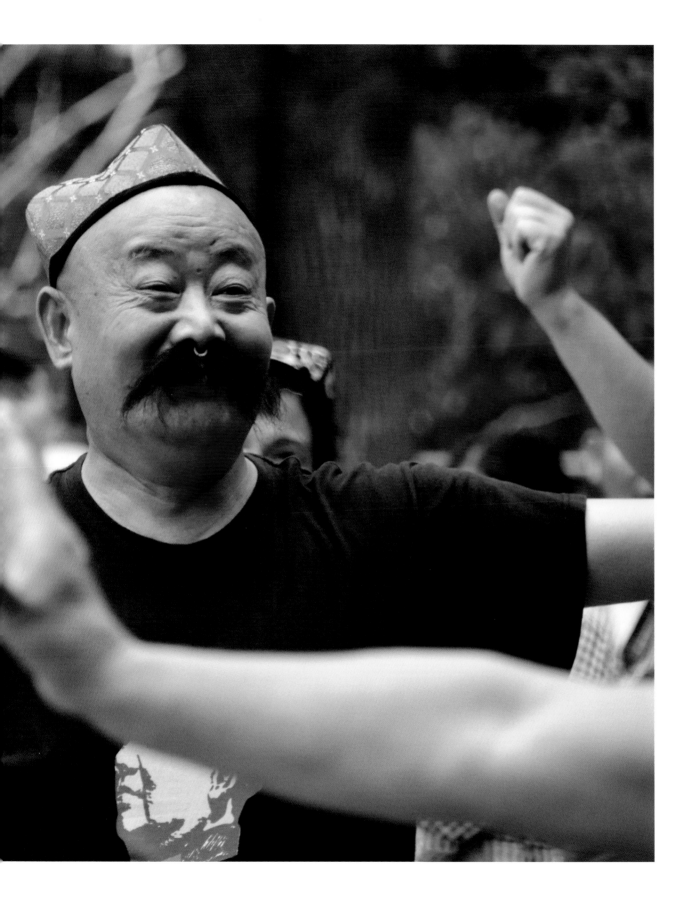

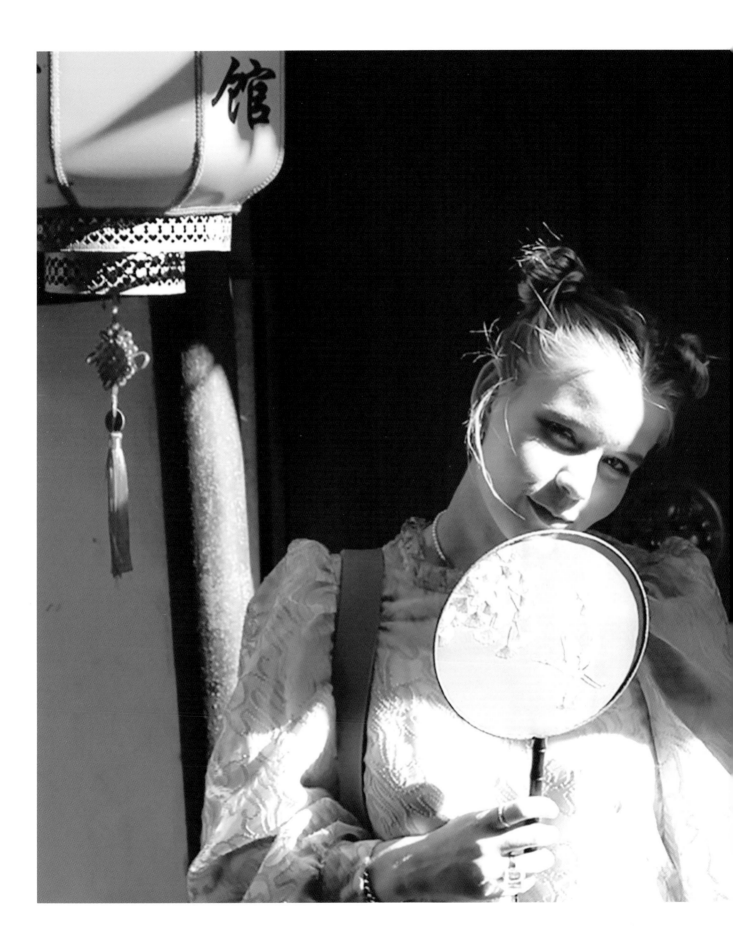

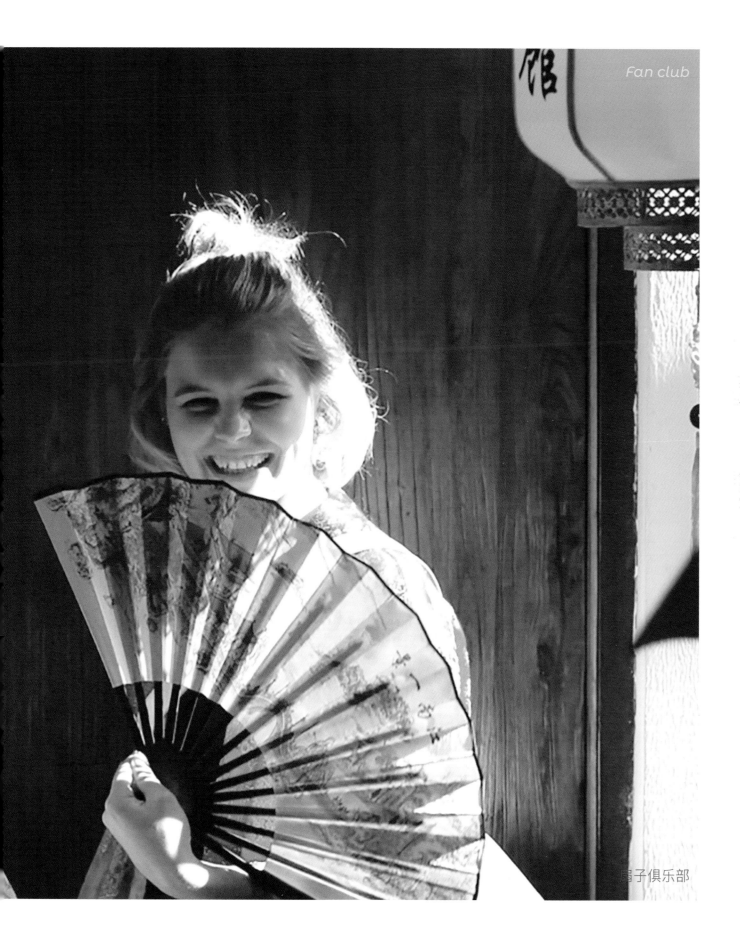

扇子俱乐部

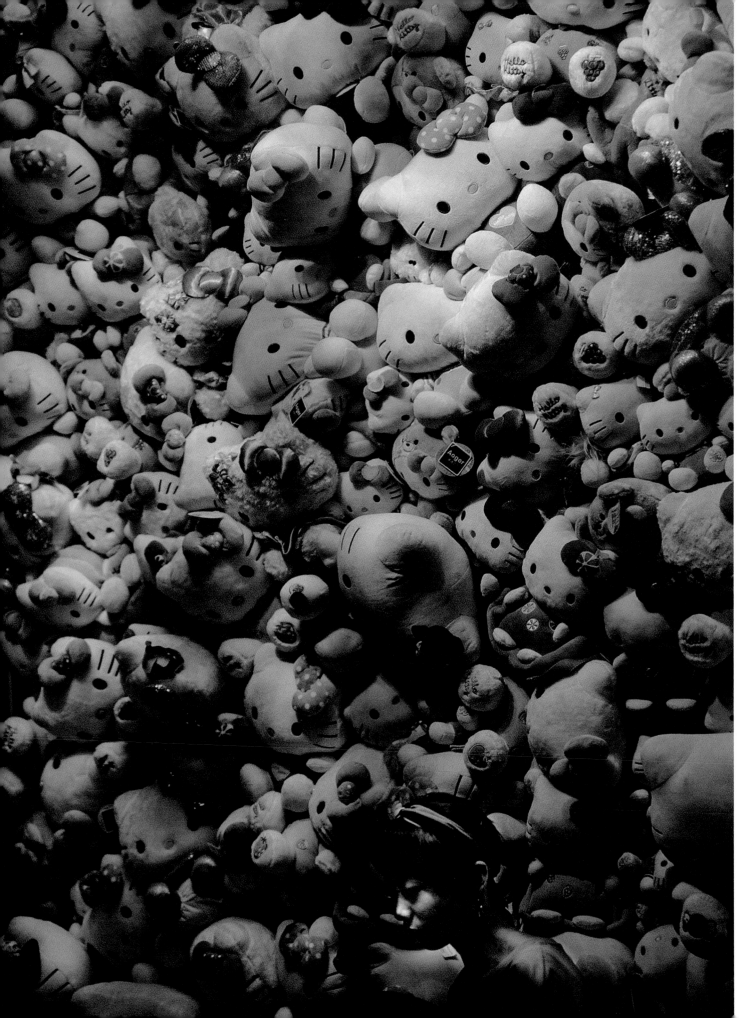

Lost in kittens

迷失

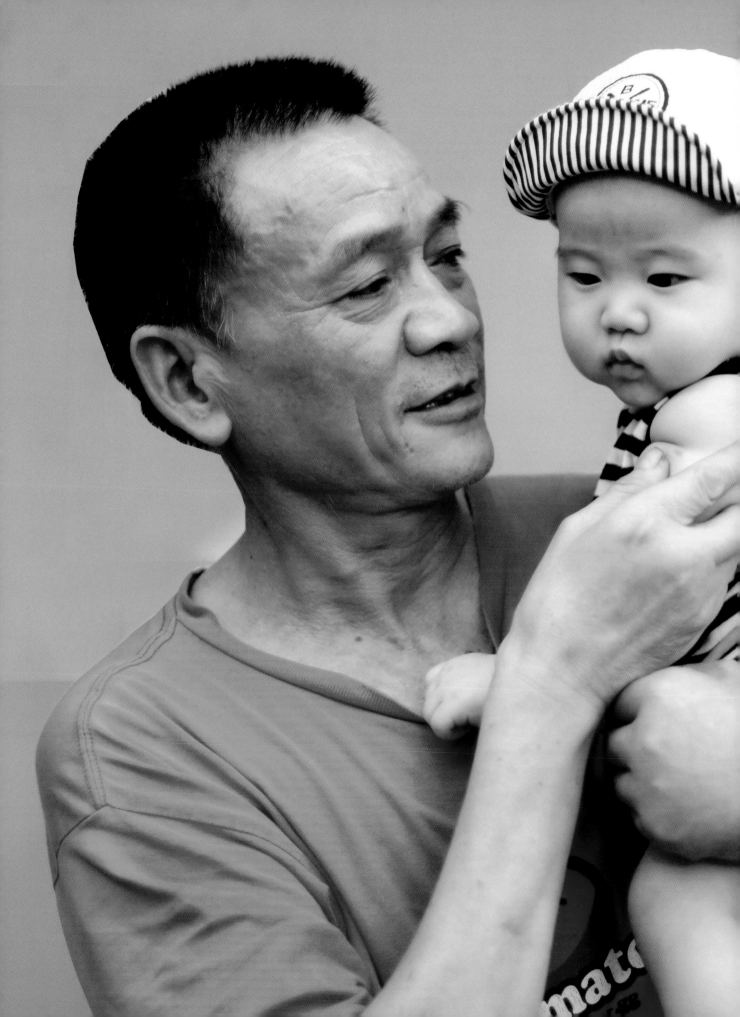

不要长大

胖脚脚

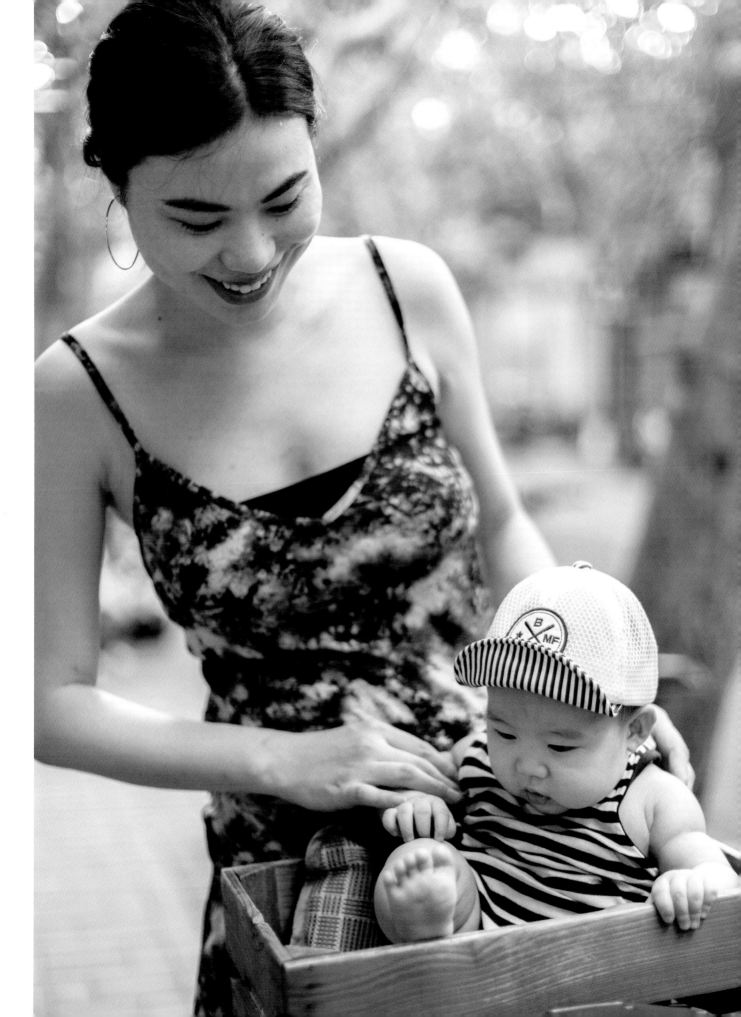

Rainbow in the rain

雨中的彩虹

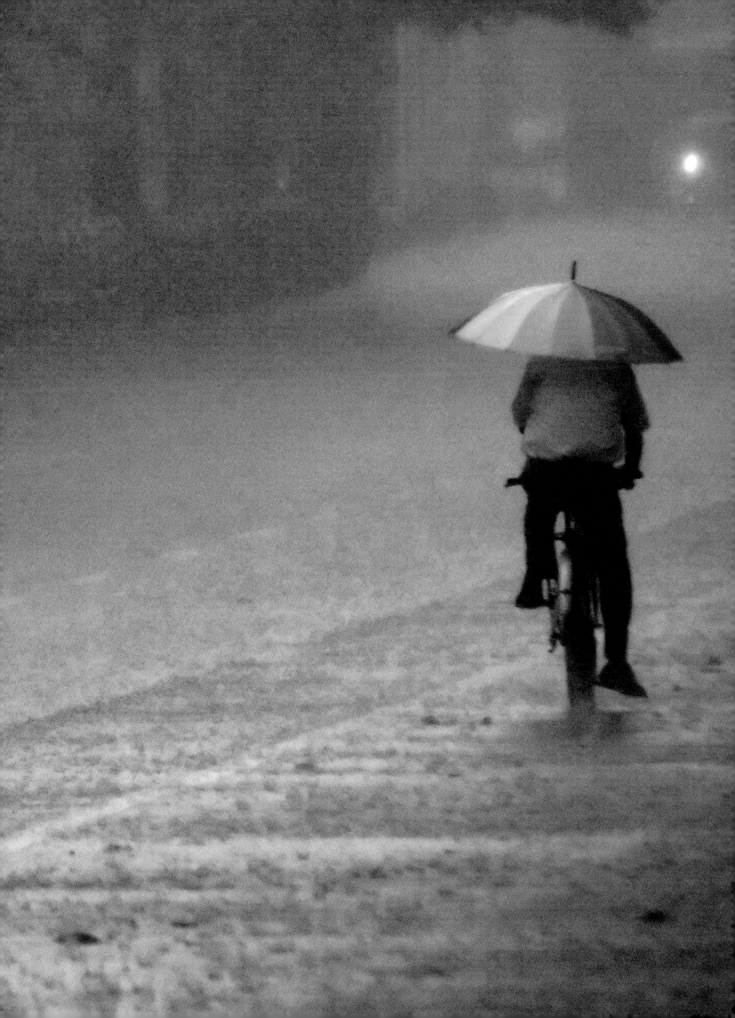

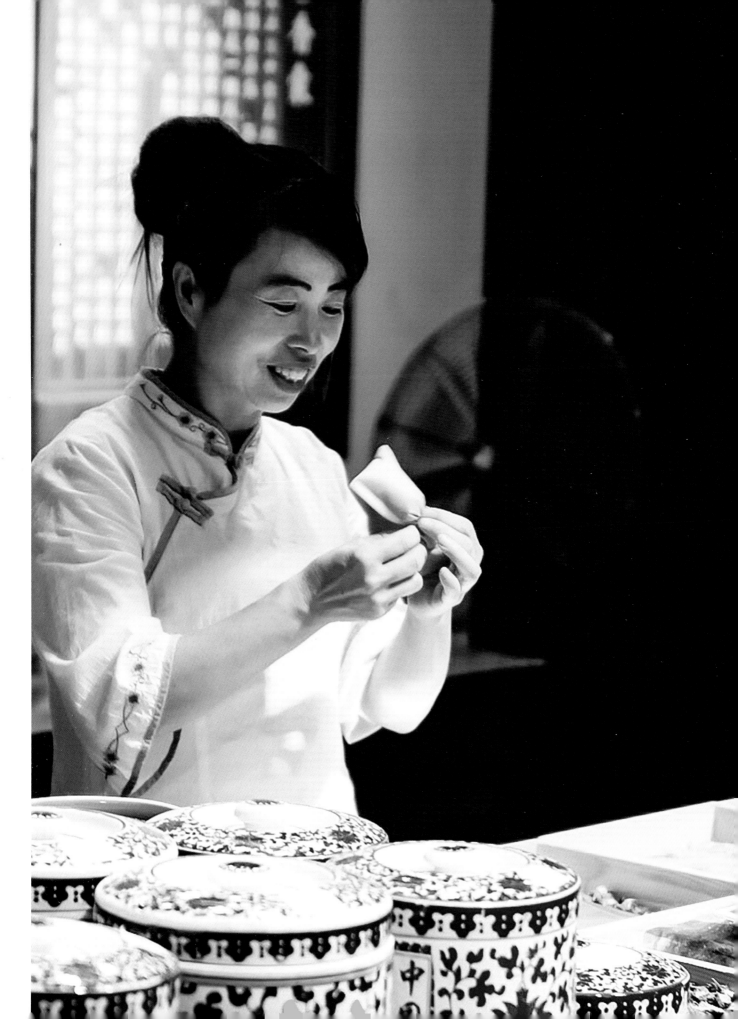

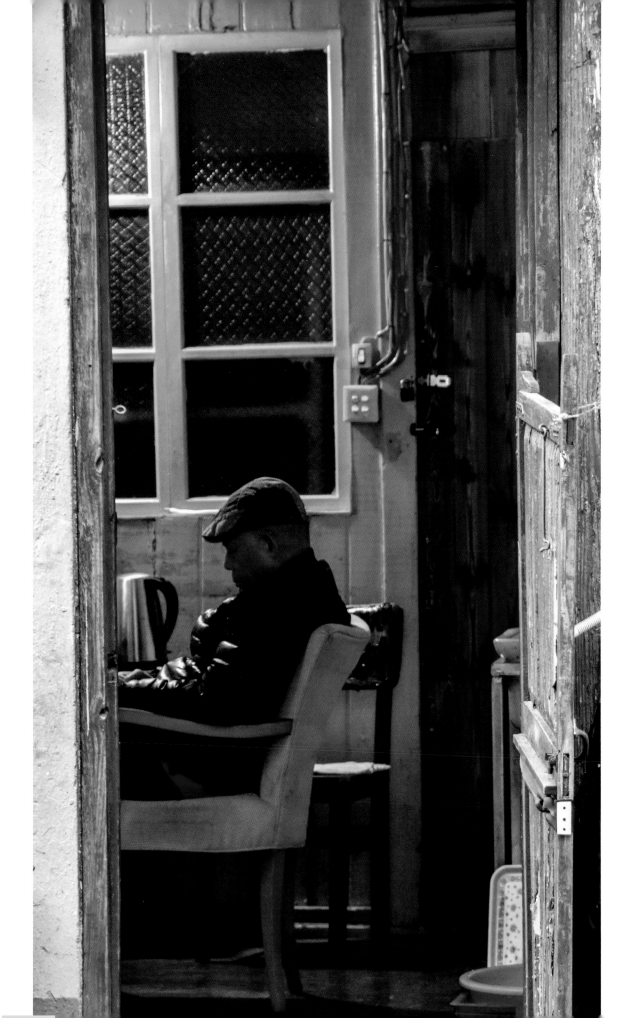

Open door

敞开的门

接住了

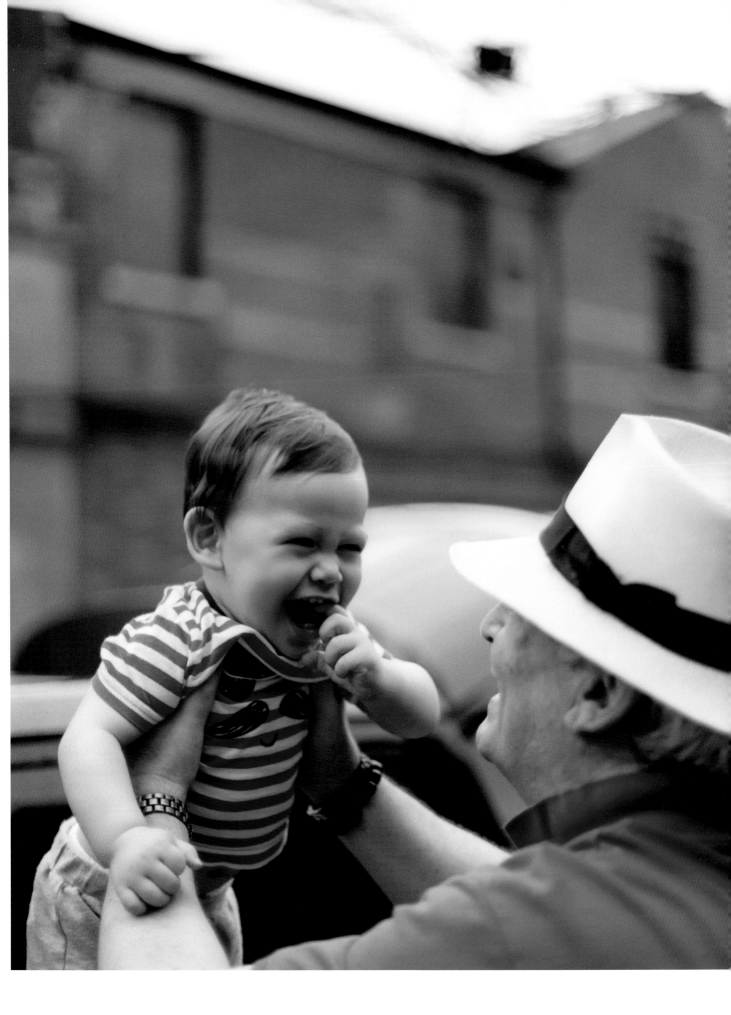

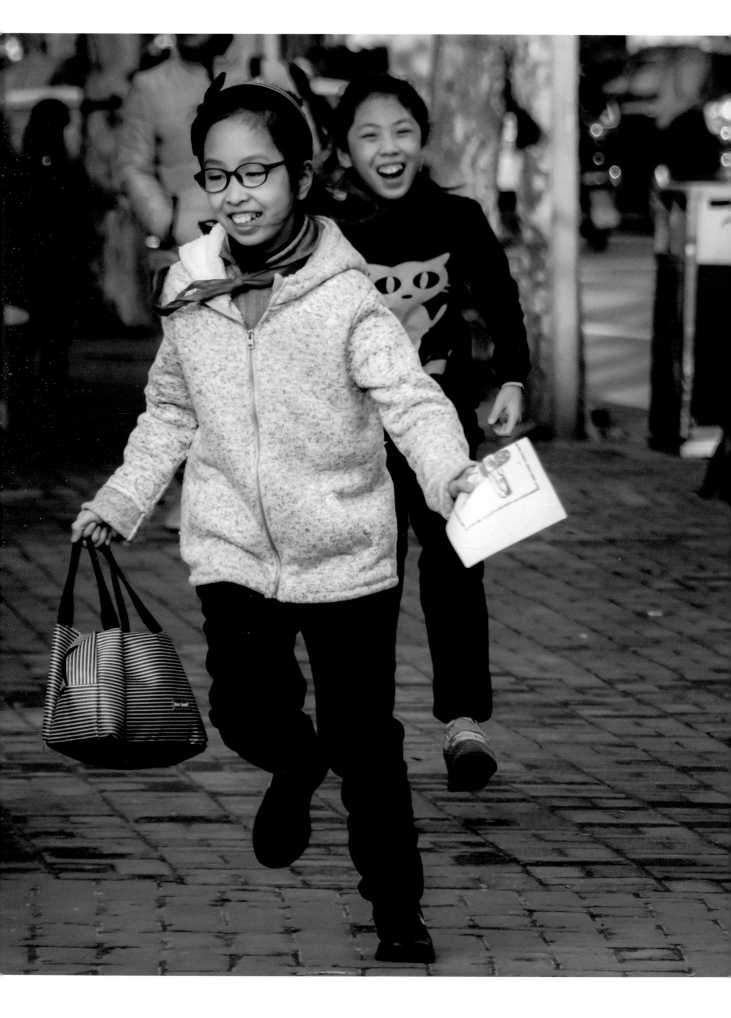

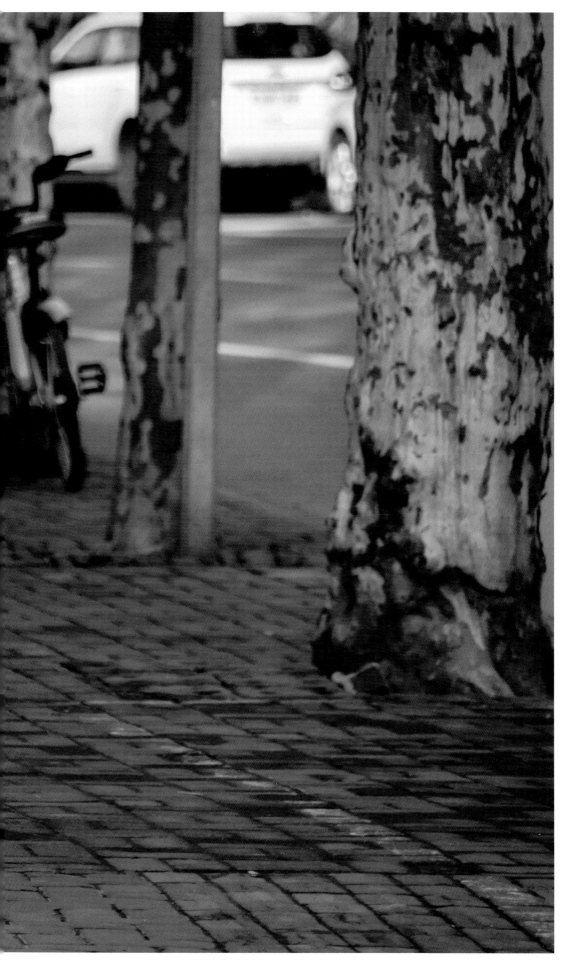

快来抓我哦

冬季漫步

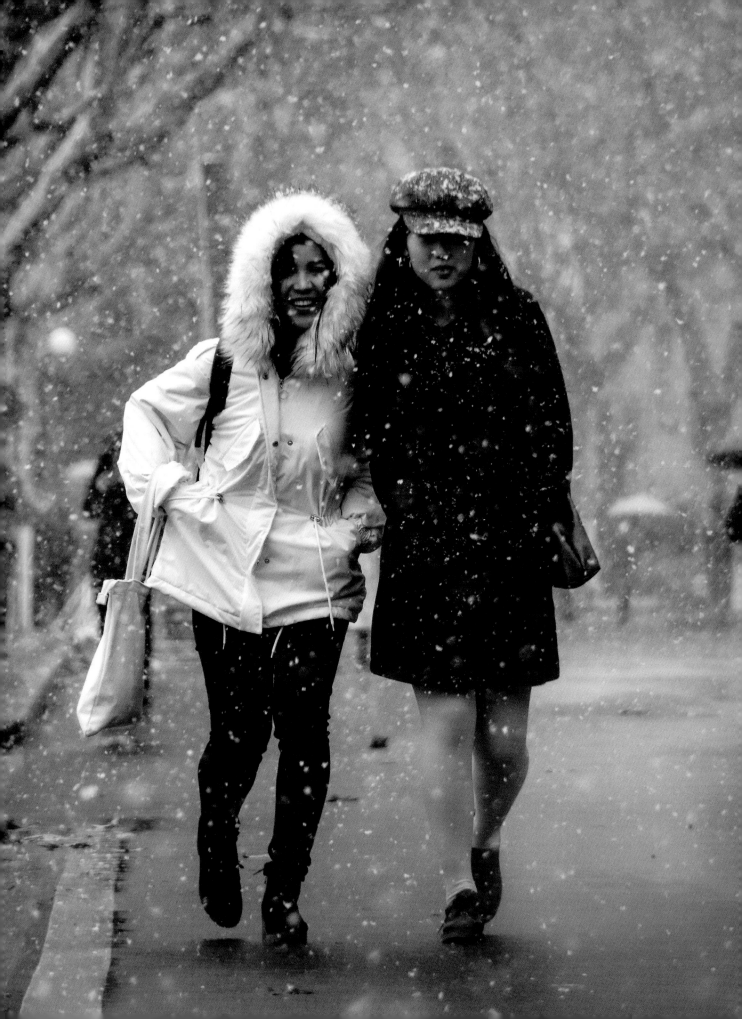

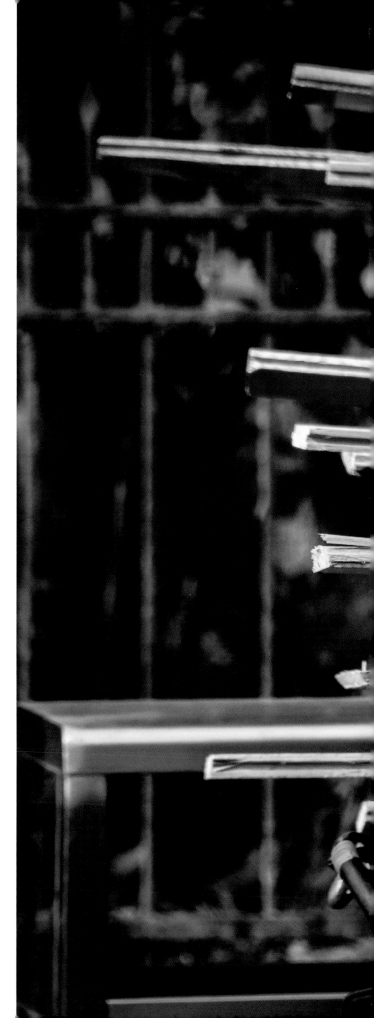

Pointing ahead

指路

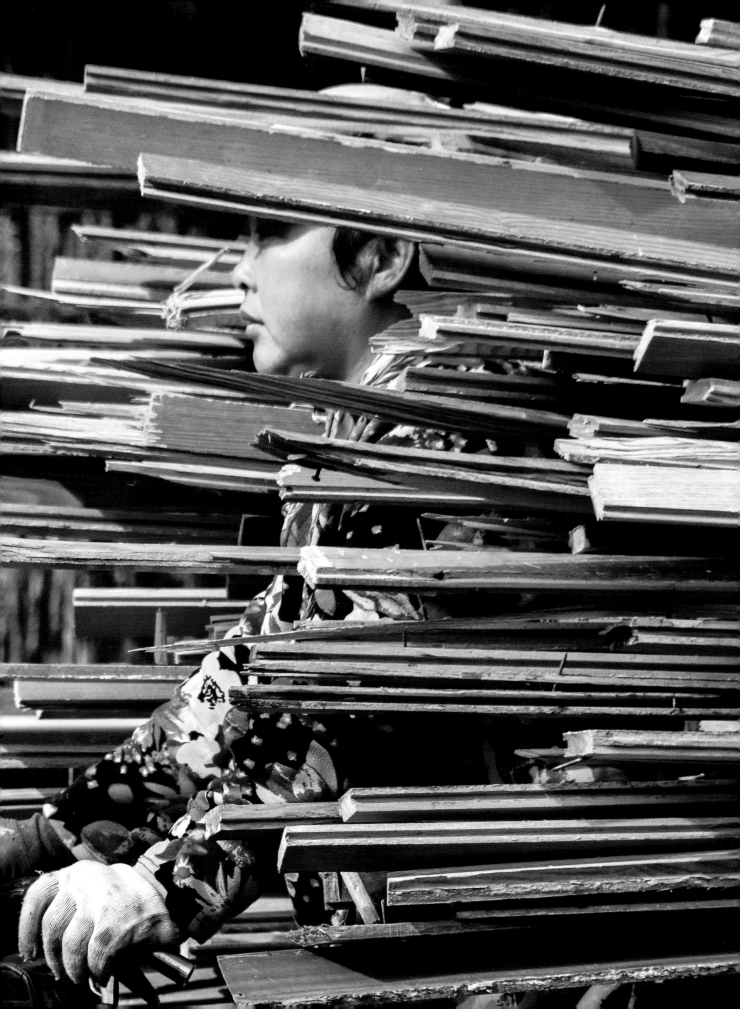

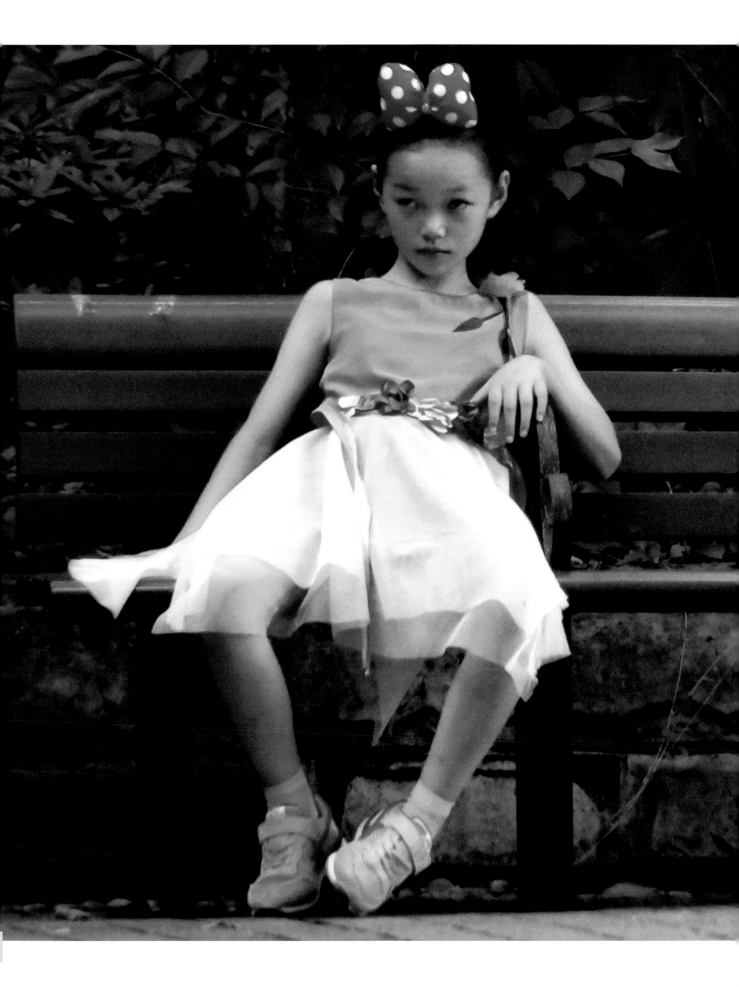

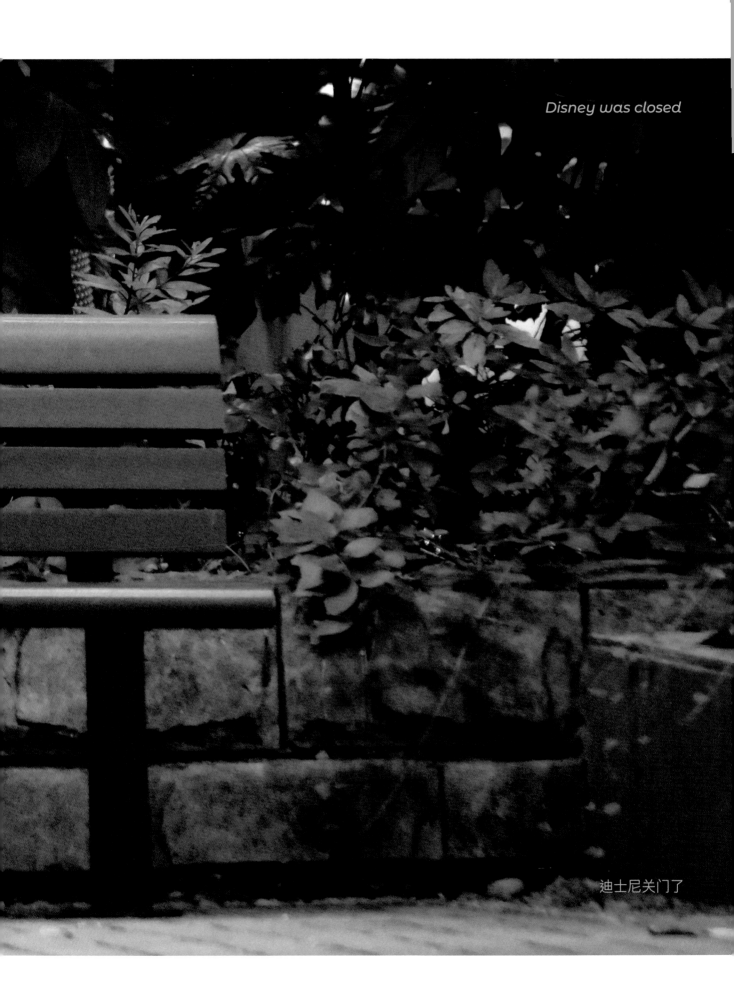

Disney was closed

迪士尼关门了

爸爸的家

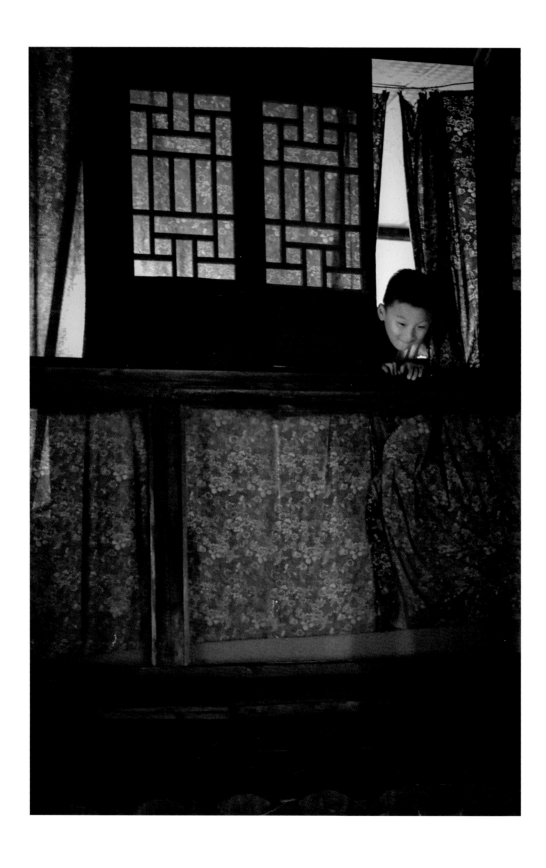

最好的
才智
并不是
人工的

Our best
intelligence
is not
artificial

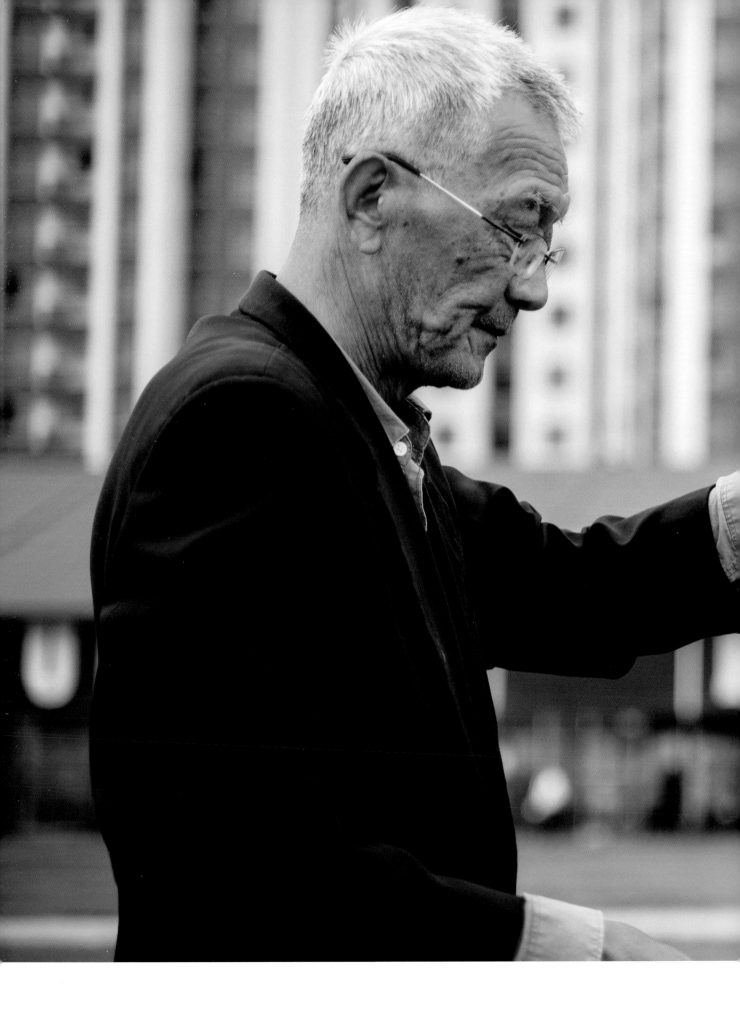

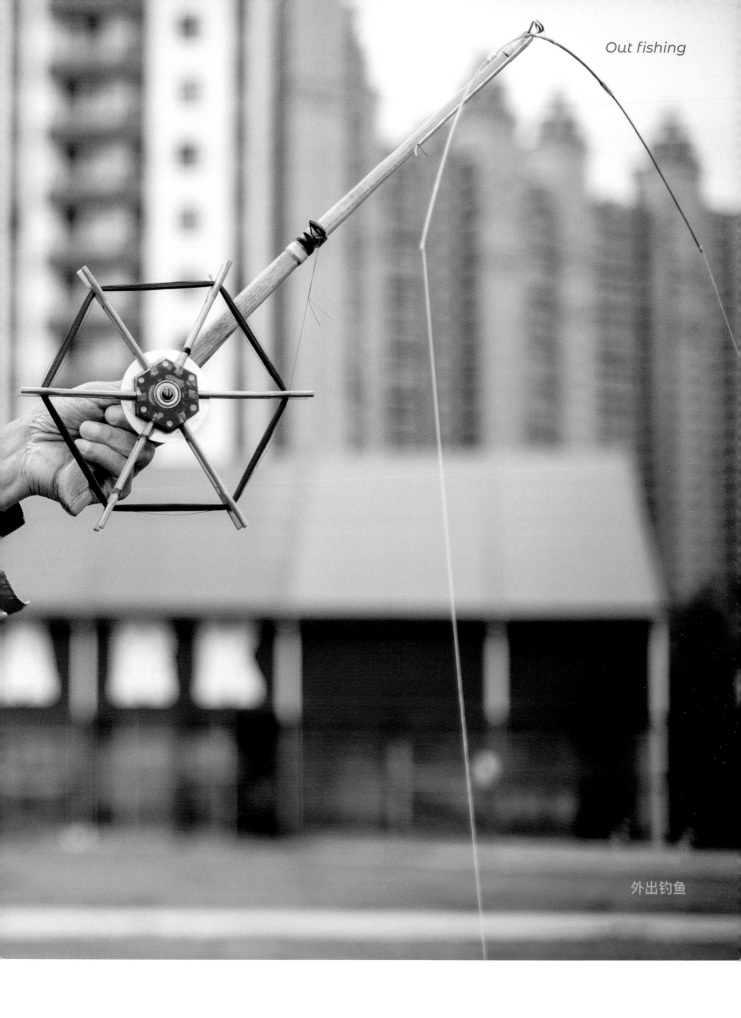

外出钓鱼

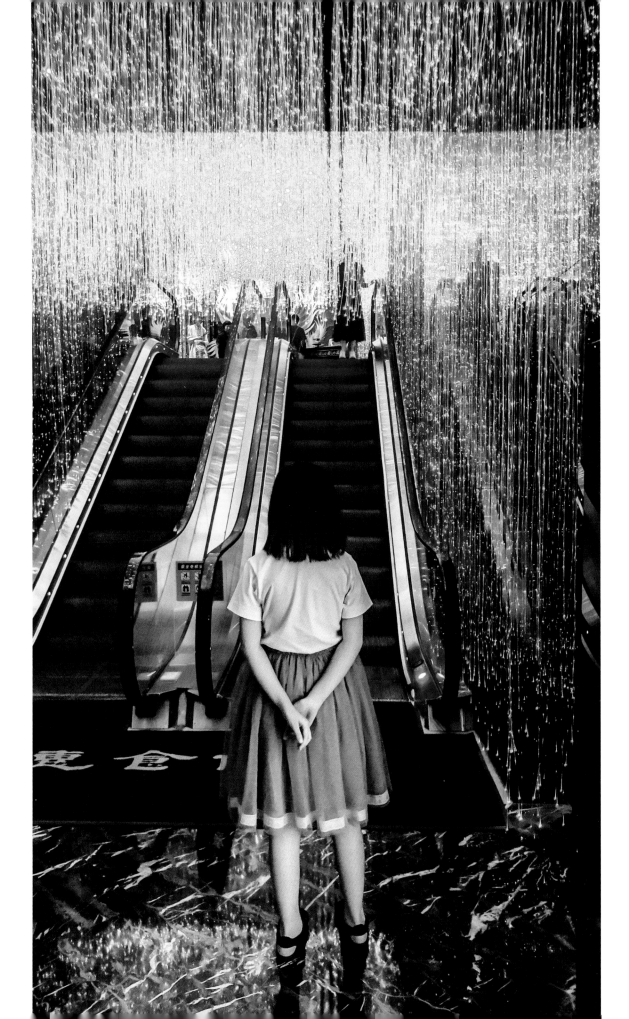

妈妈的店

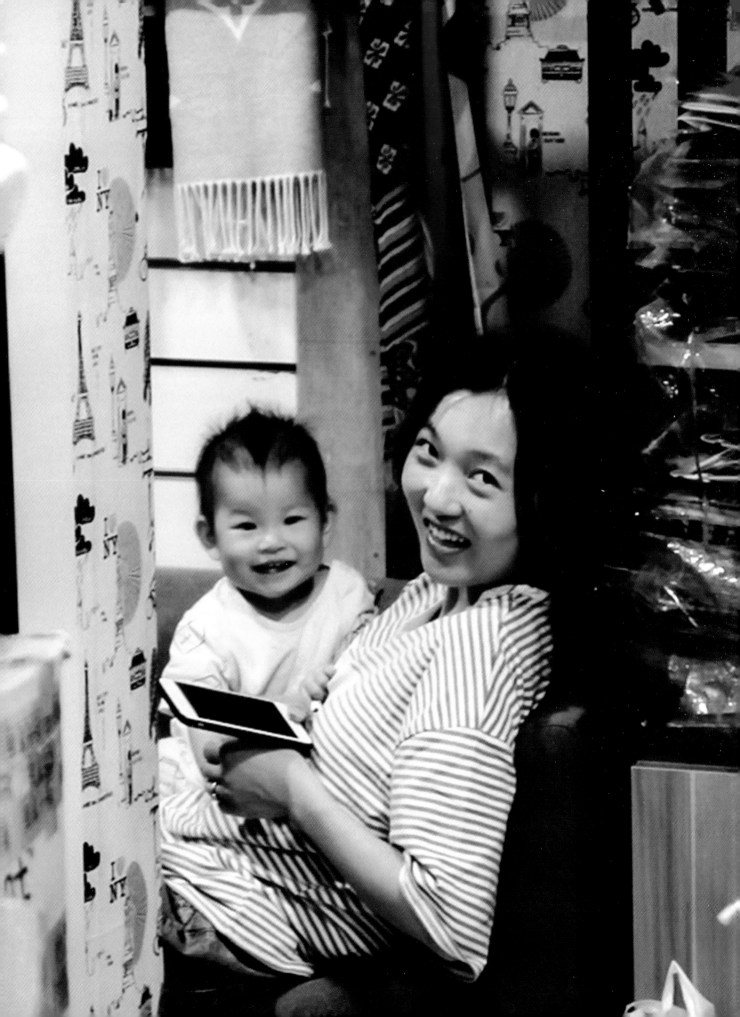

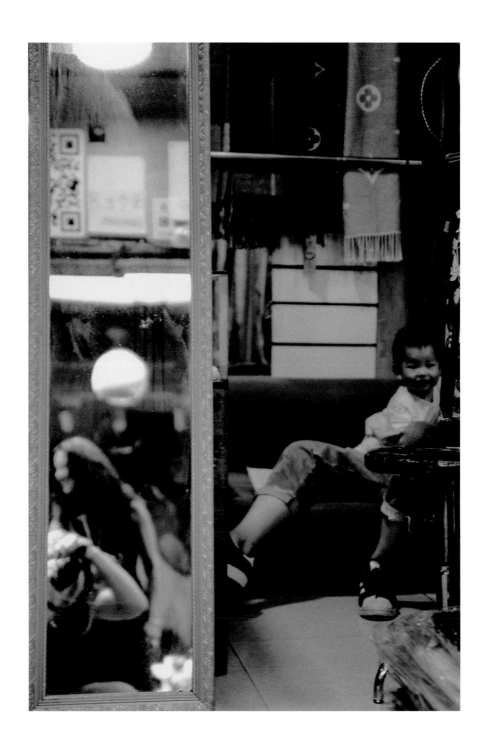

Capturing Mom's shop

妈妈店里的日常

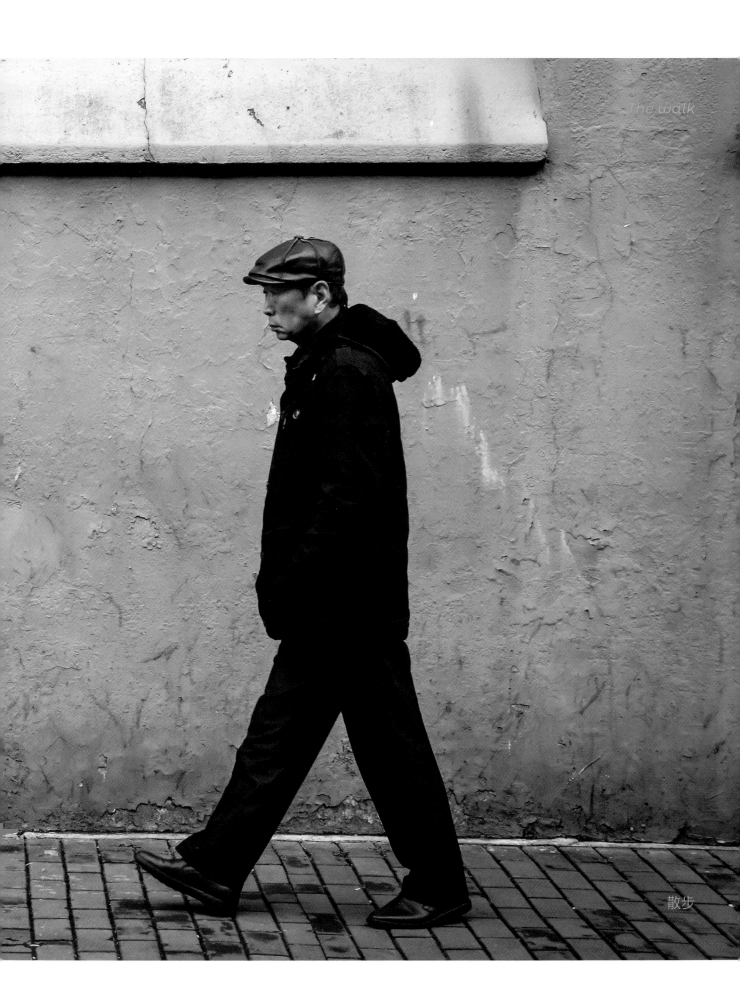

The walk

散步

Shop window

櫥窗

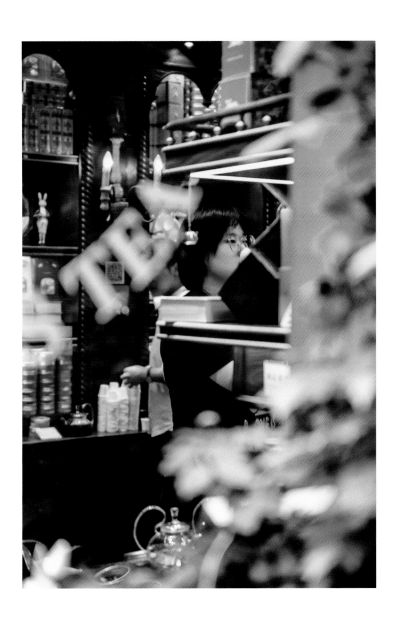

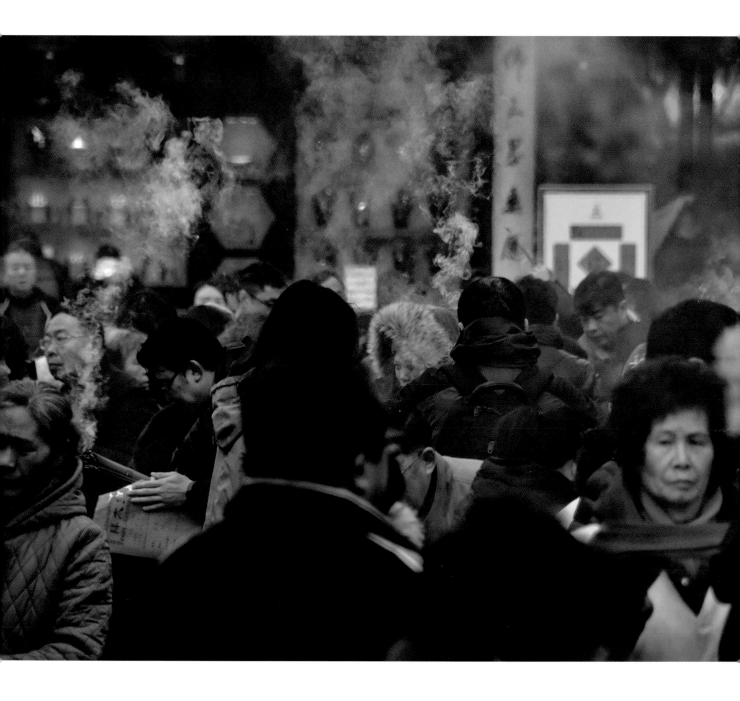

人群中的脸

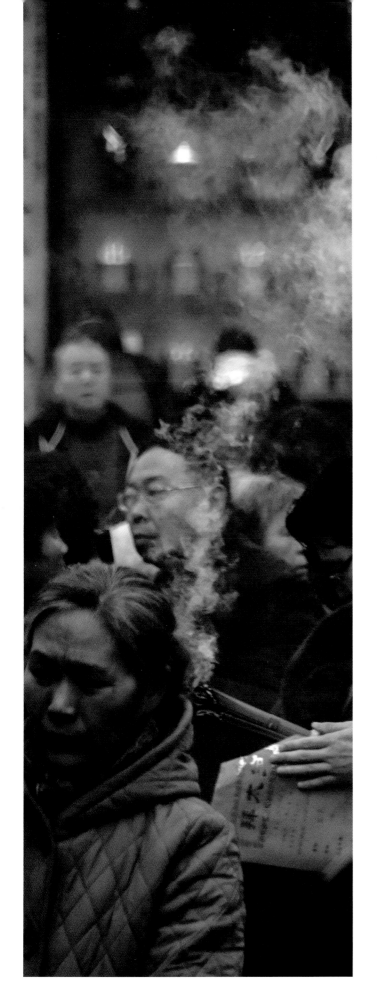
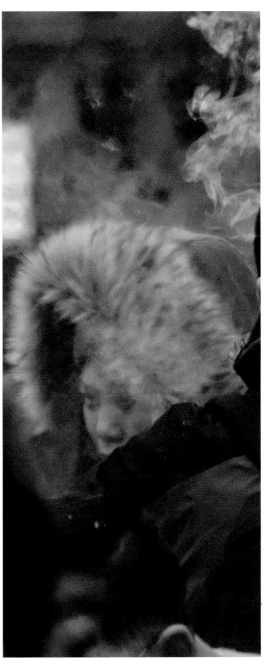

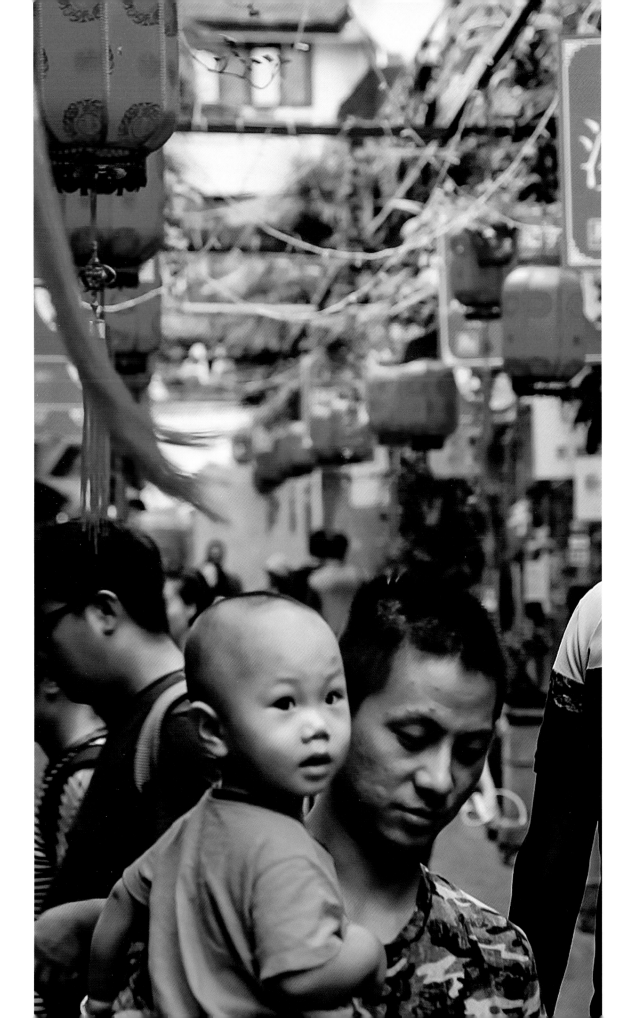

弄堂

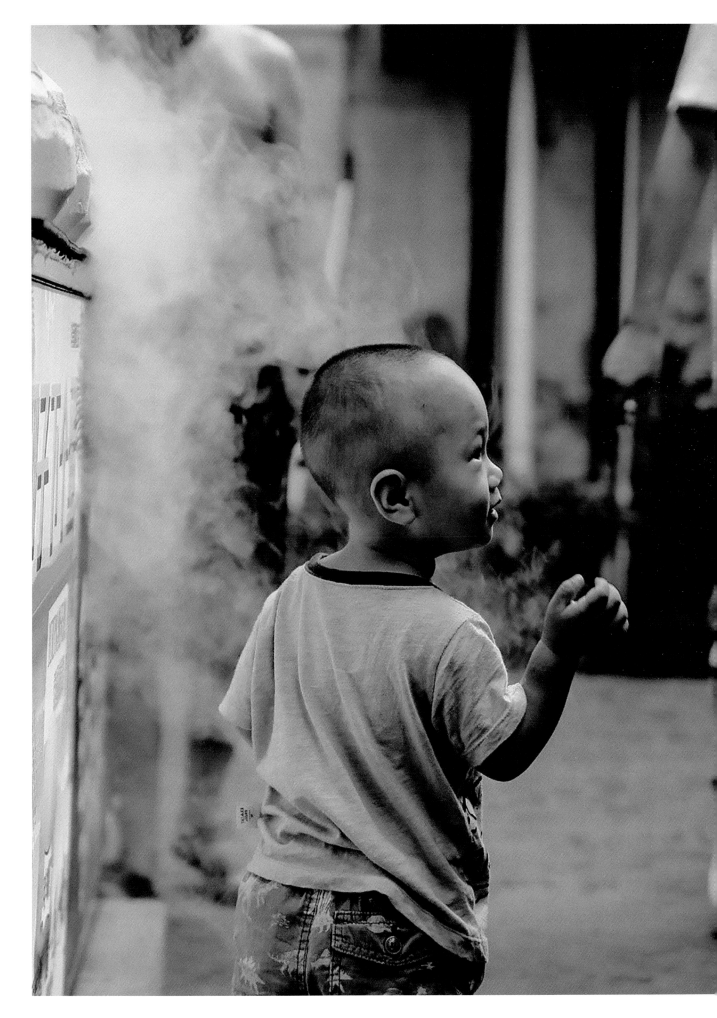

真朋友
时刻显出
爱心
圣经

益友难得
中国谚语

A true friend
shows love
at all times

The Bible

A faithful friend
is
hard to find

Chinese proverb

Young love

青梅竹马

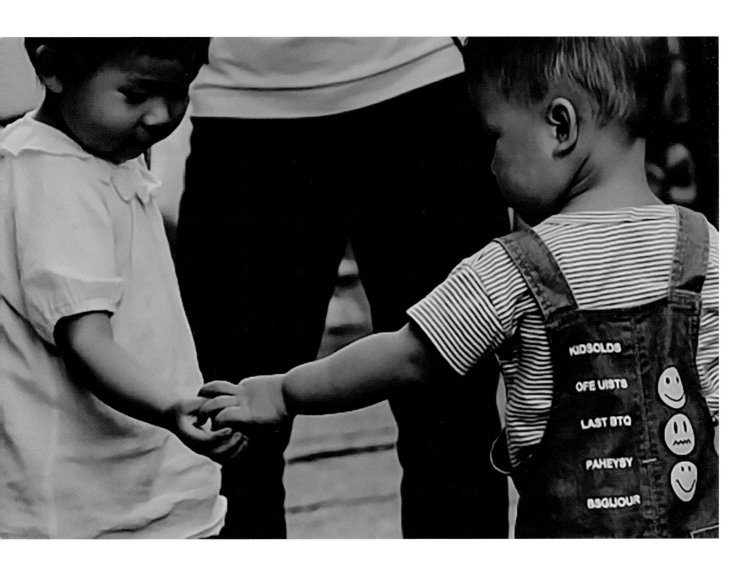

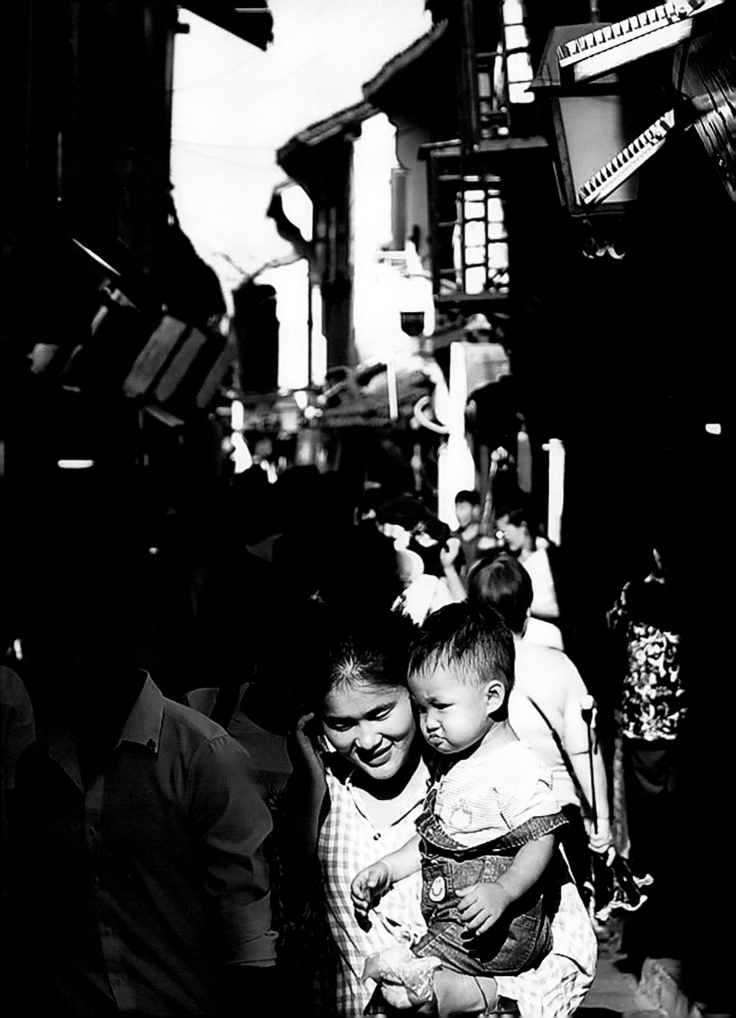

水乡

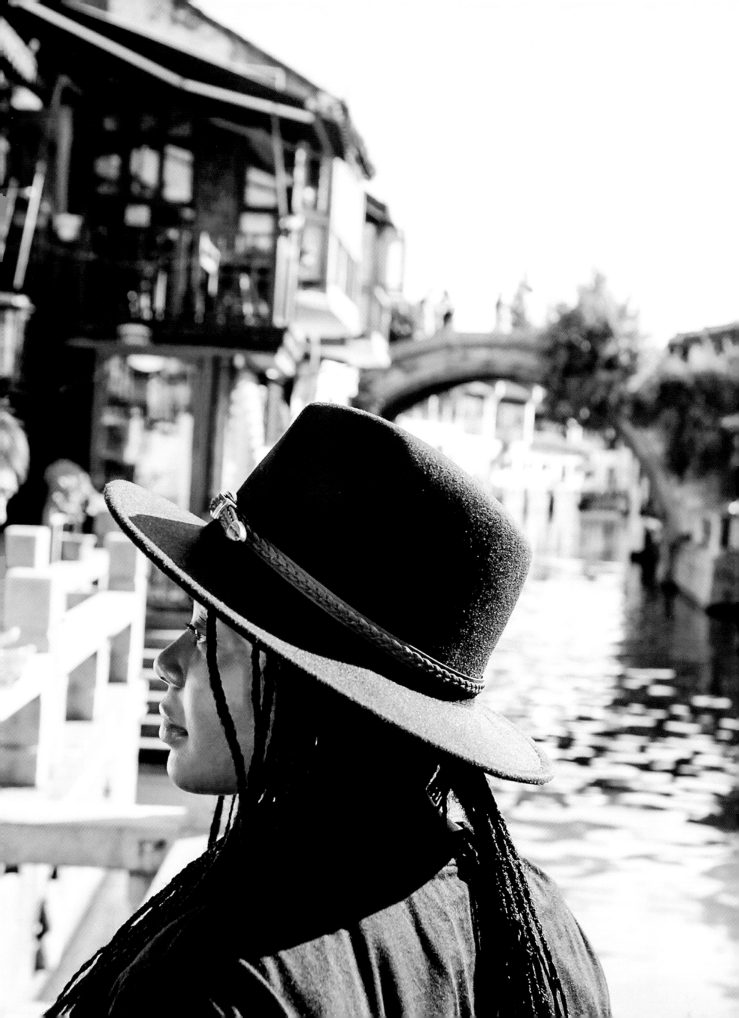

Big sister

大姐姐

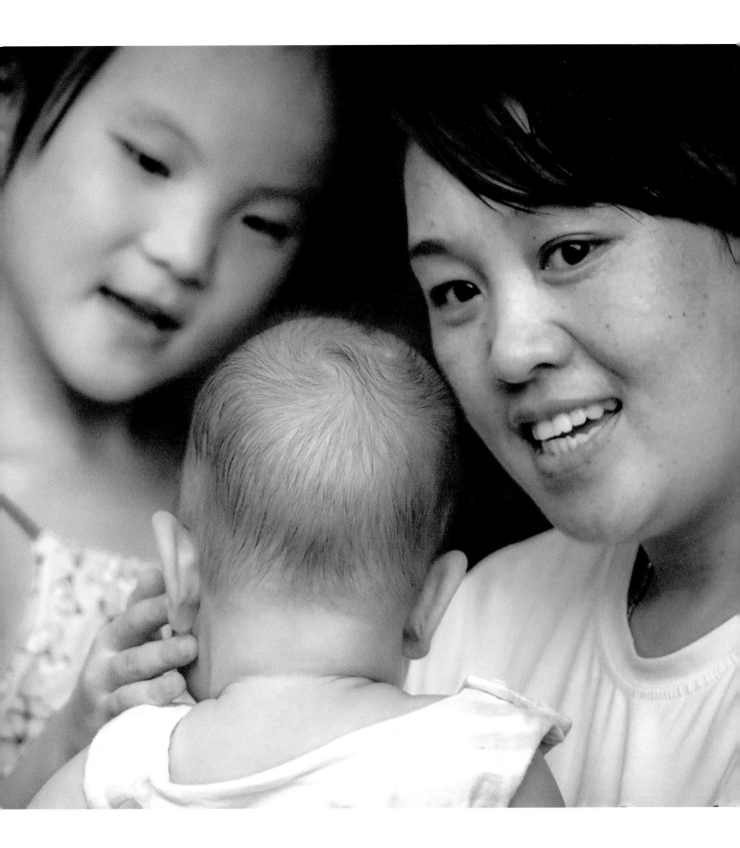

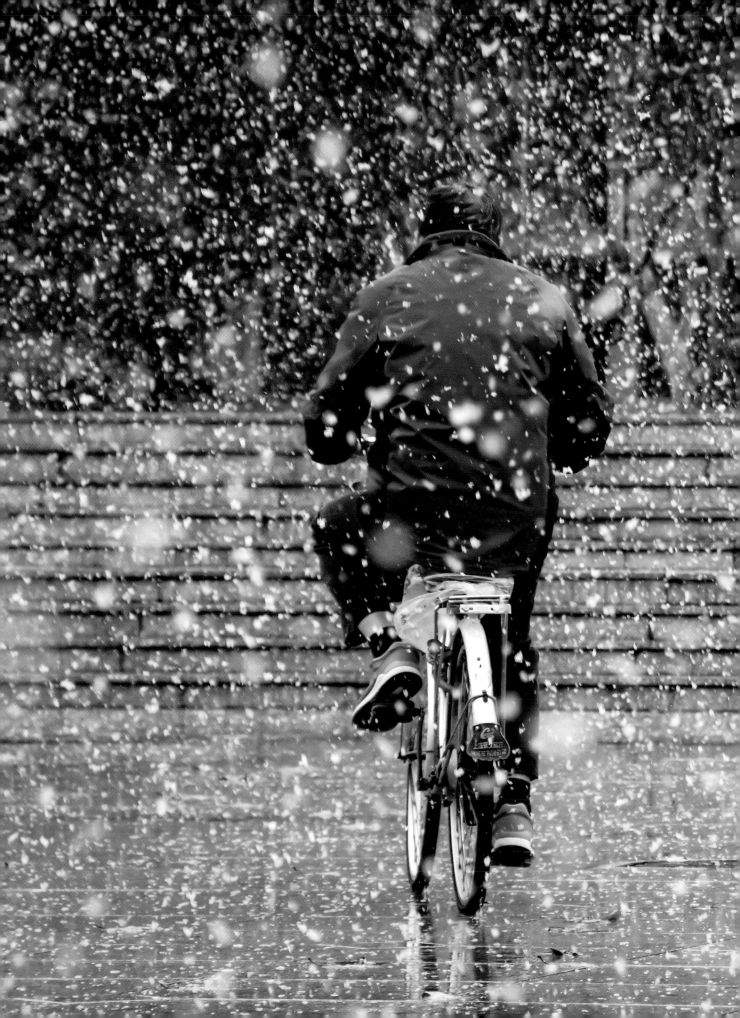

Solitary cyclist

独自骑行

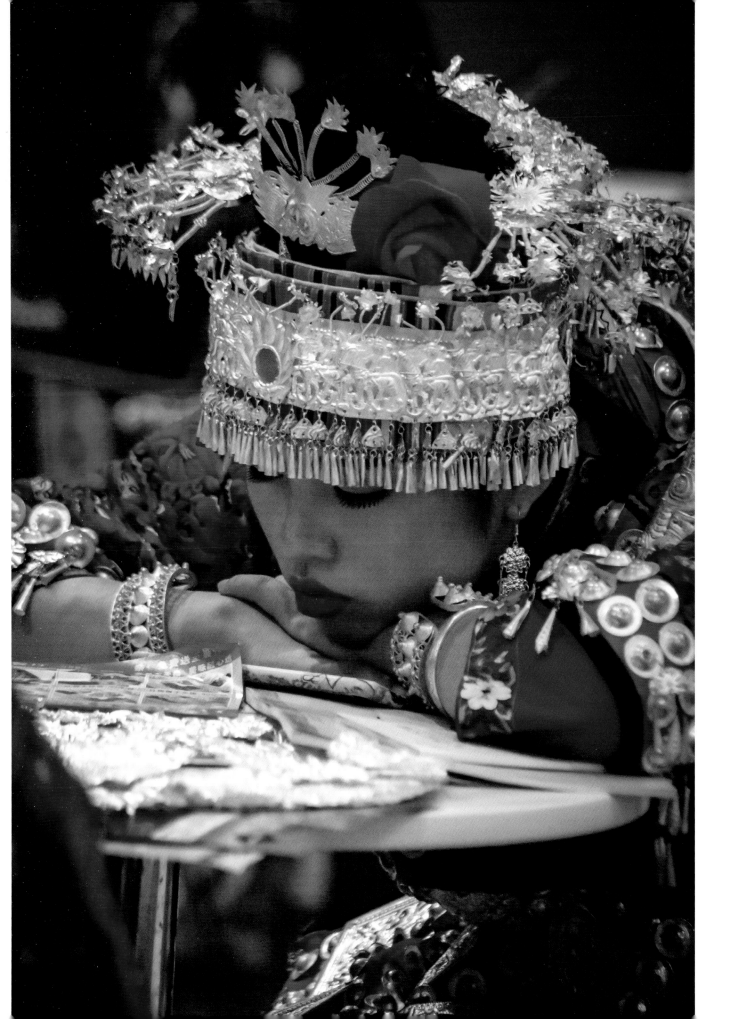

微笑
创造
微笑

Smiles
create
smiles

风干

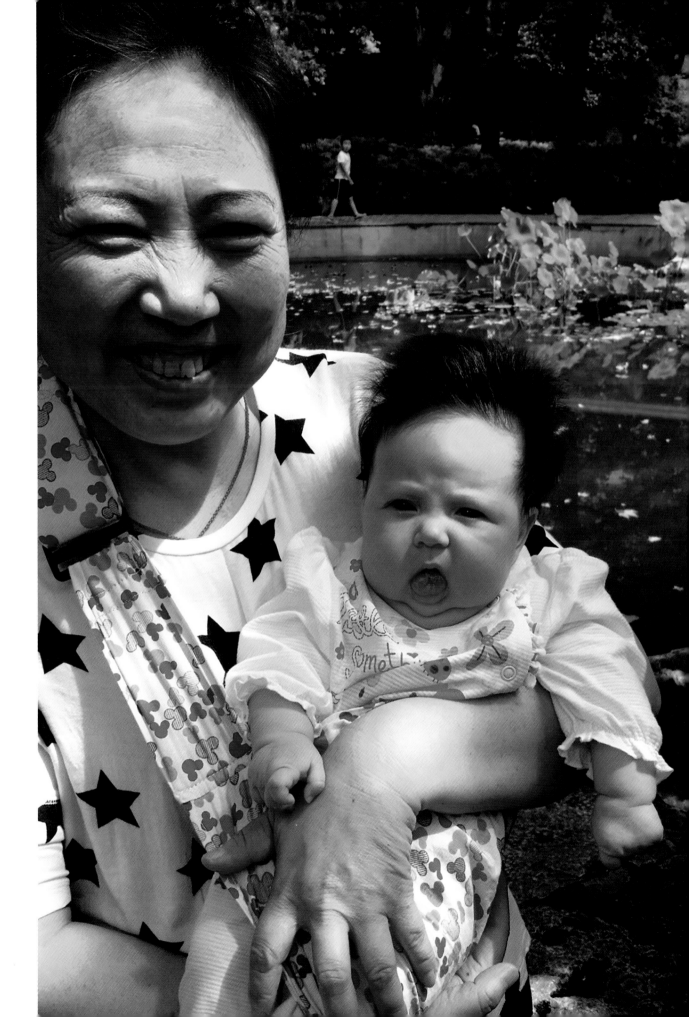

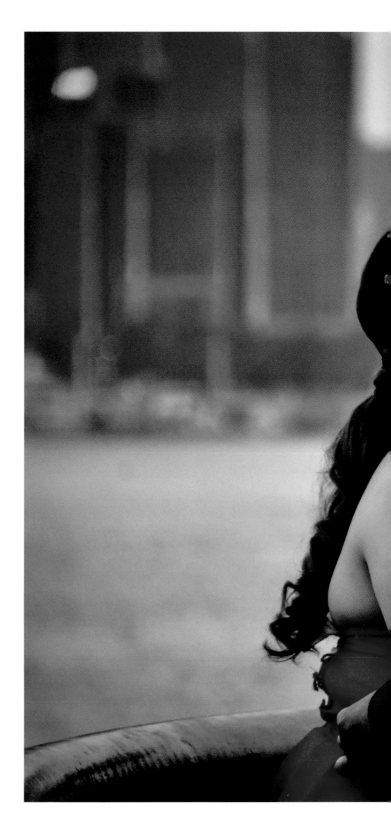

She said "Yes!"

她说"好!"

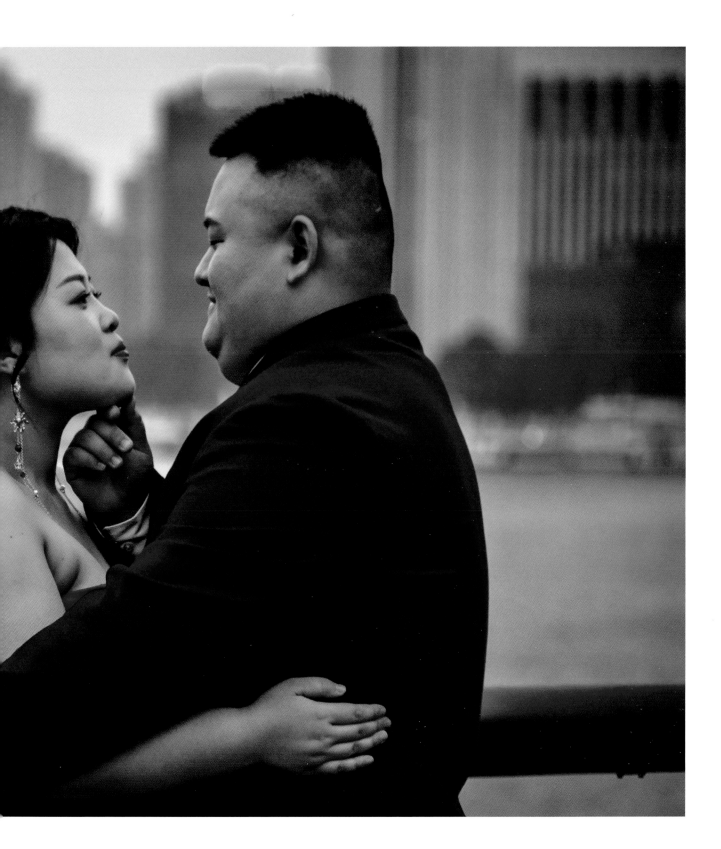

睡衣派对

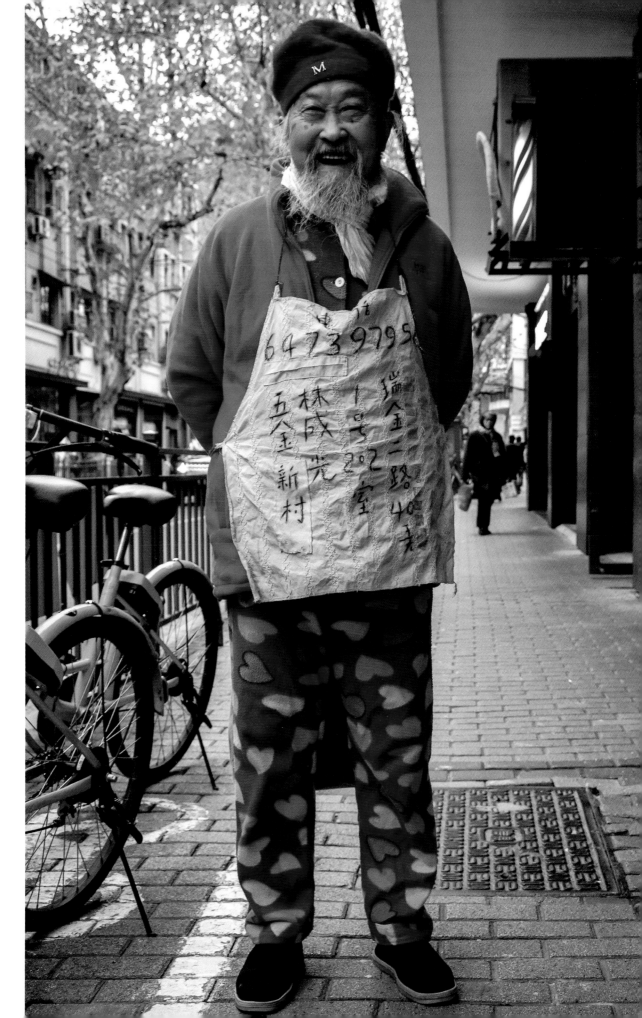

爷爷的怀抱

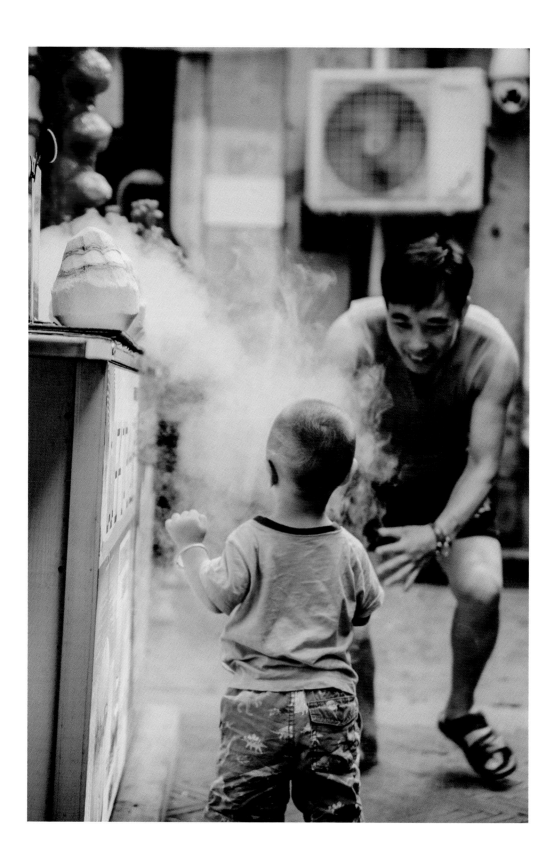

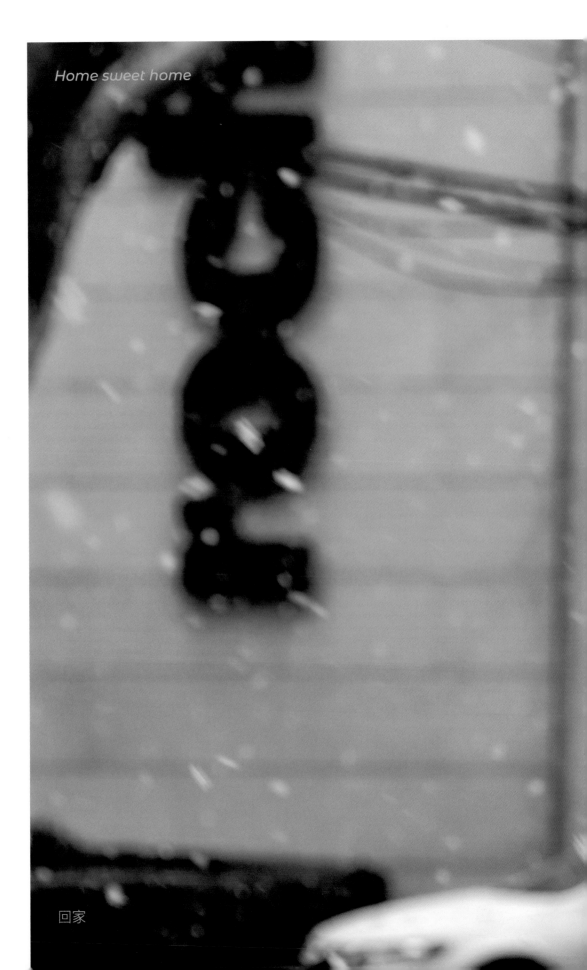

Home sweet home

回家

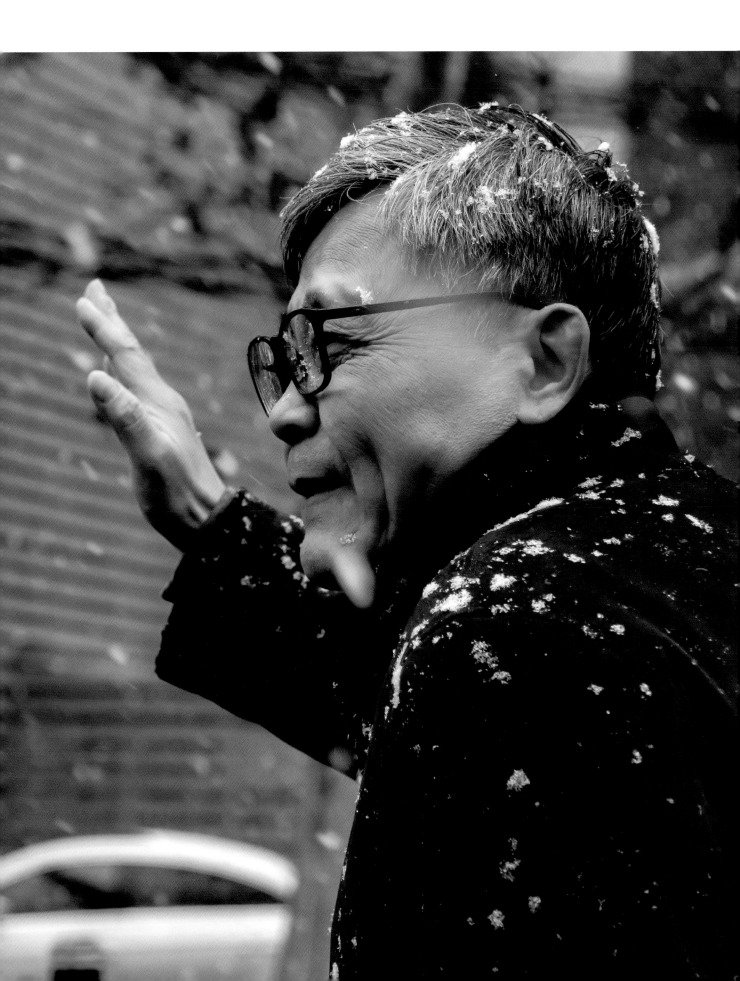

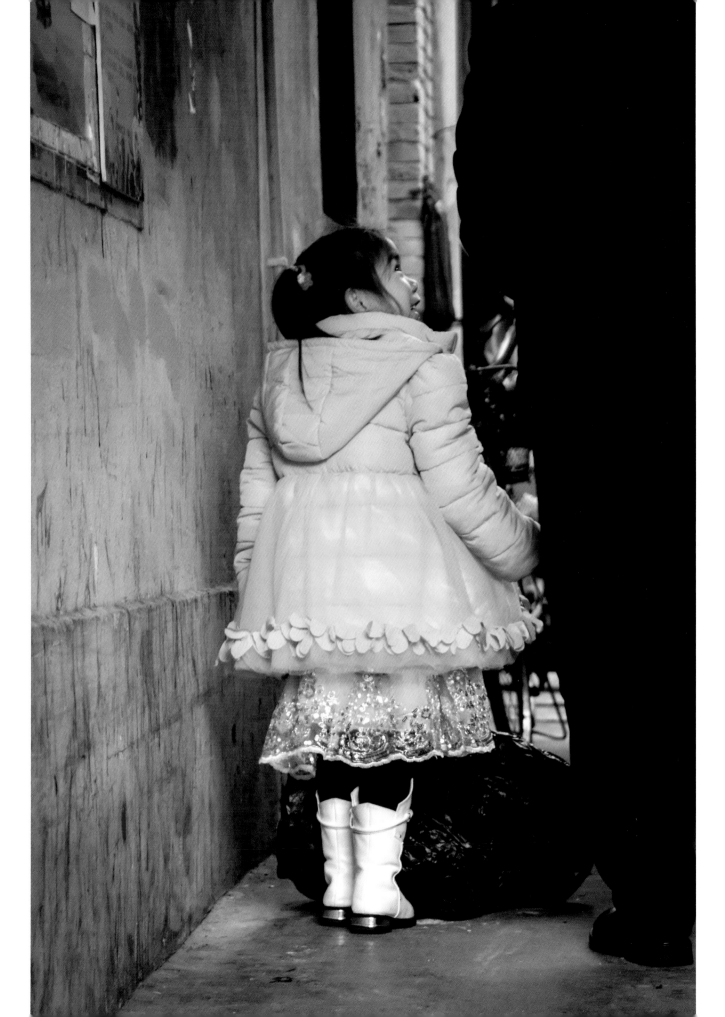

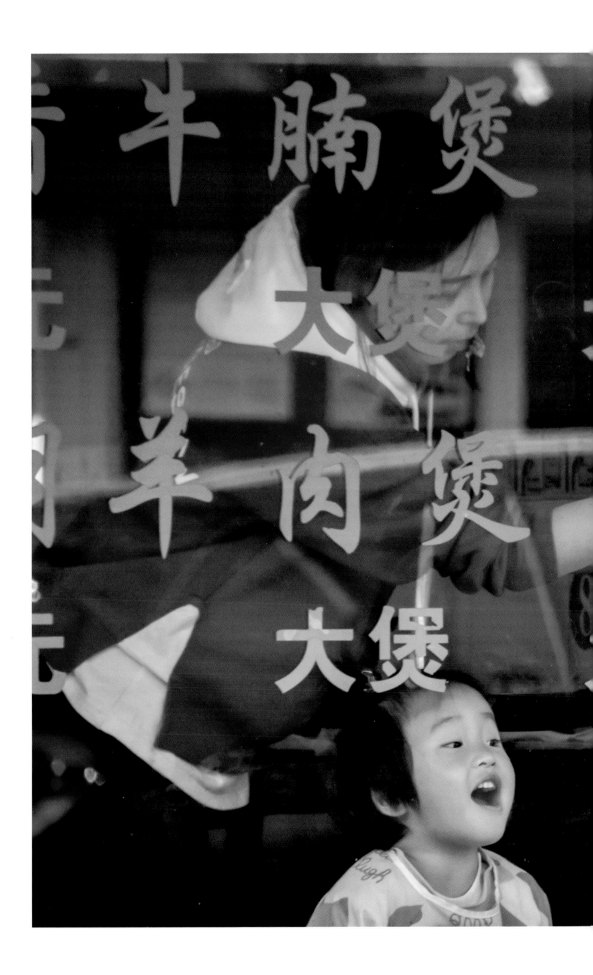

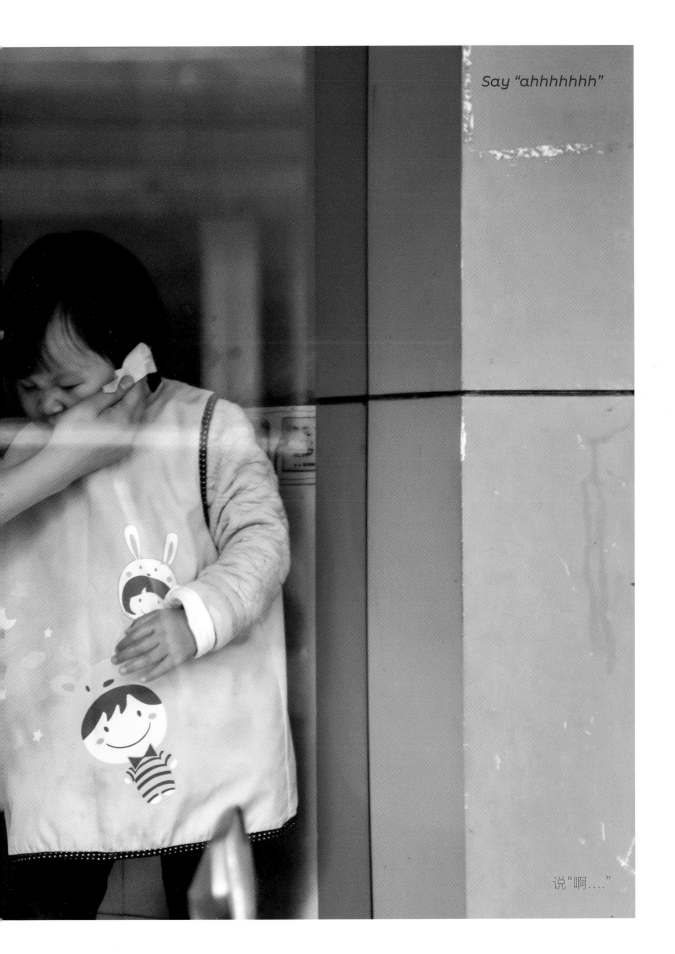

Say "ahhhhhhh"

说"啊...."

You can't draw
a person
without
shadows

人无完人

素描

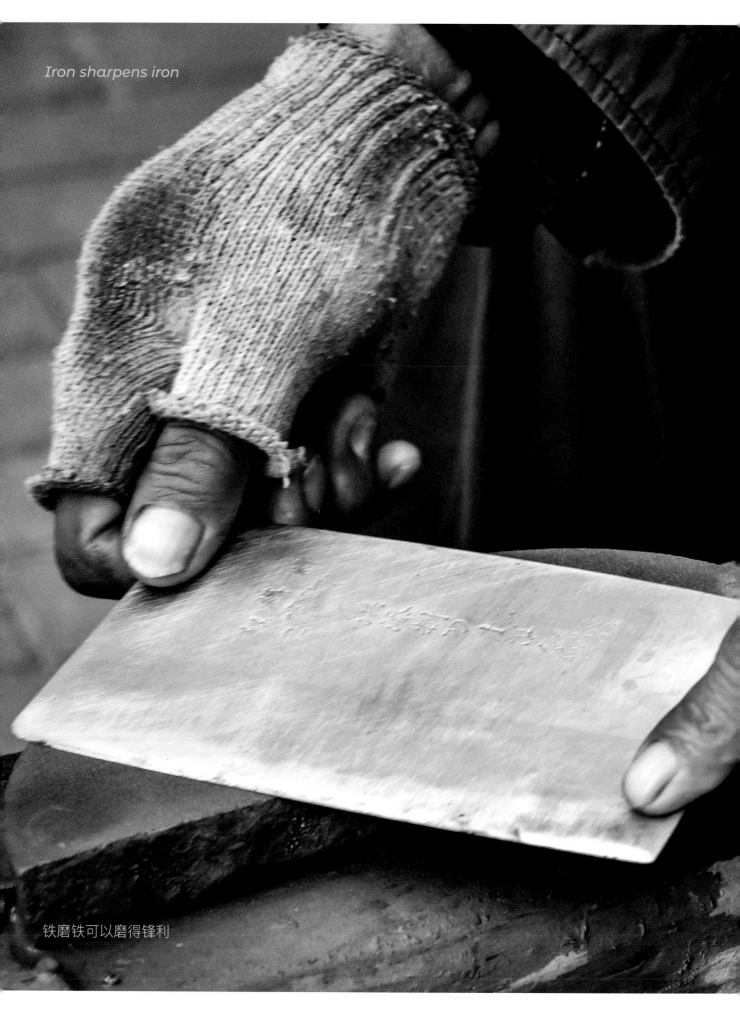

Iron sharpens iron

铁磨铁可以磨得锋利

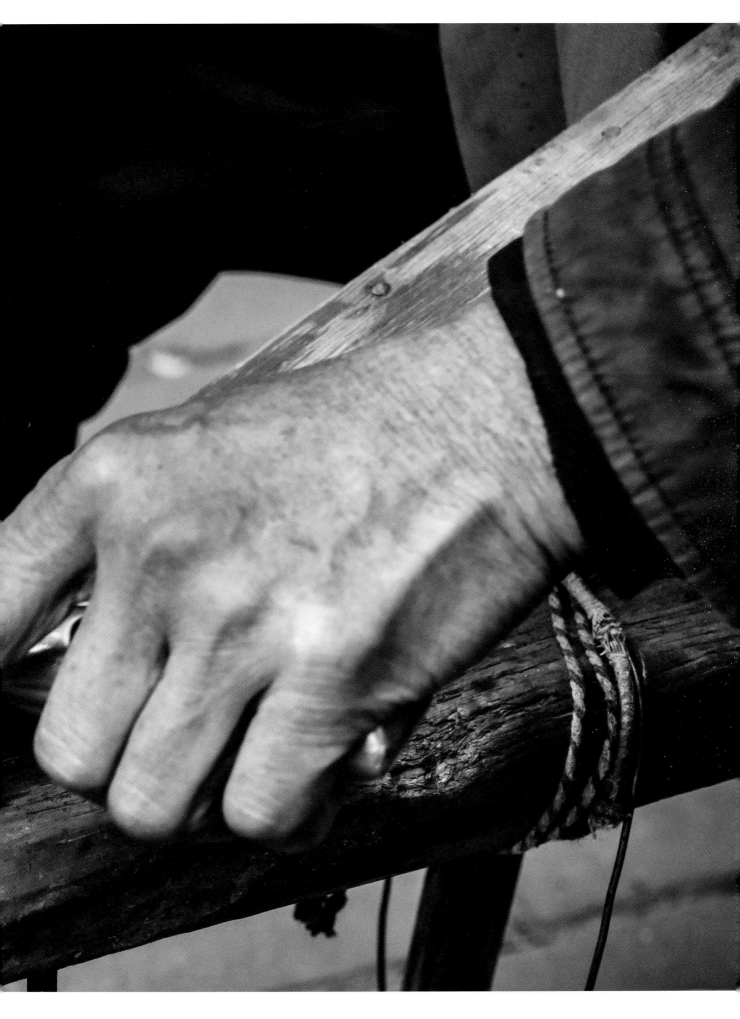

Tree-lined

树列

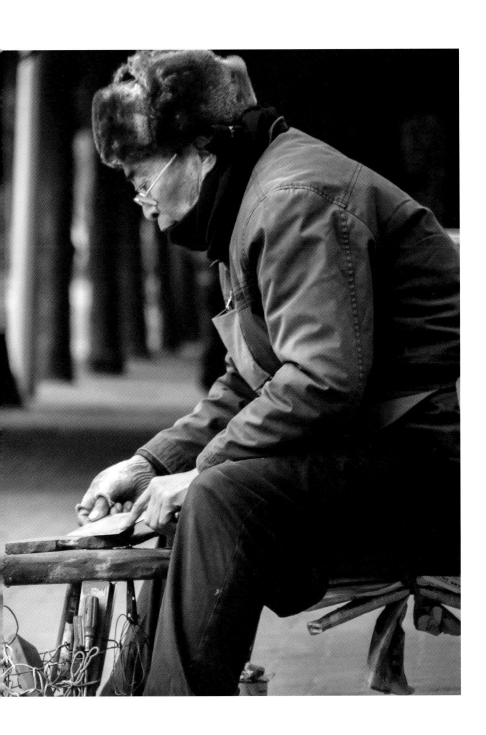

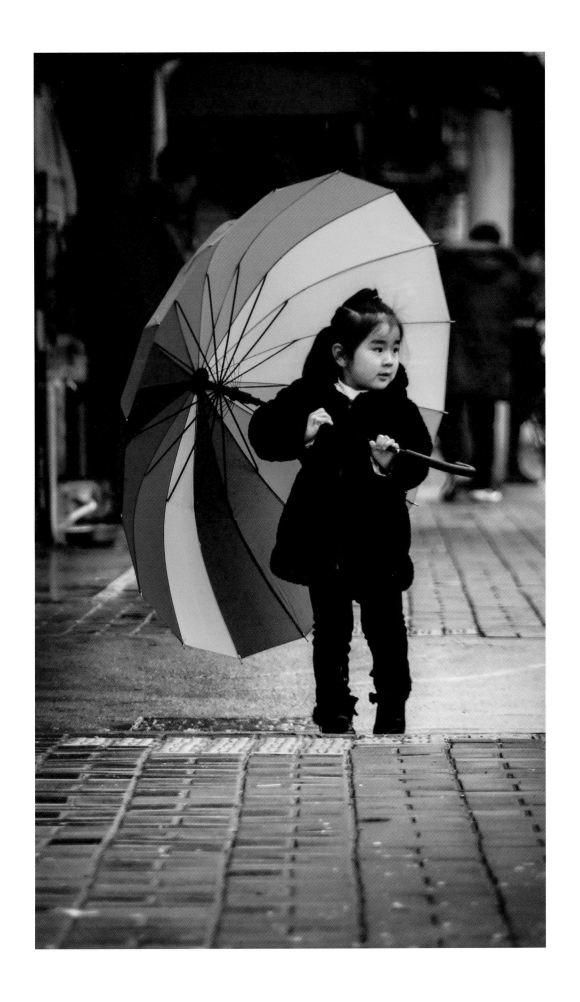

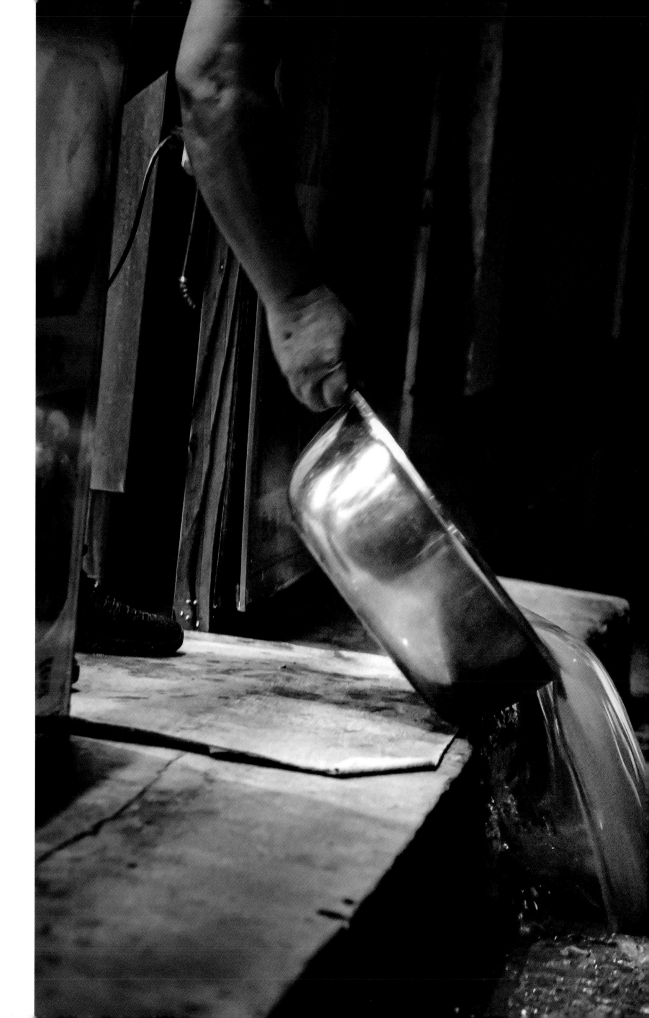

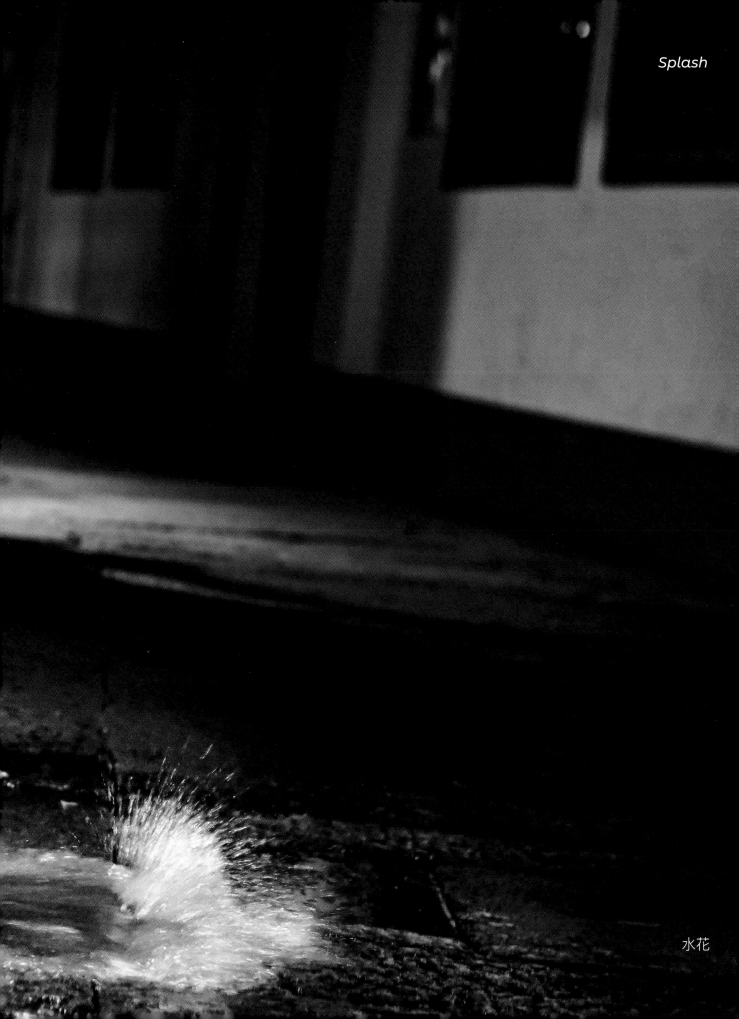

Splash

水花

Titanic

泰坦尼克号

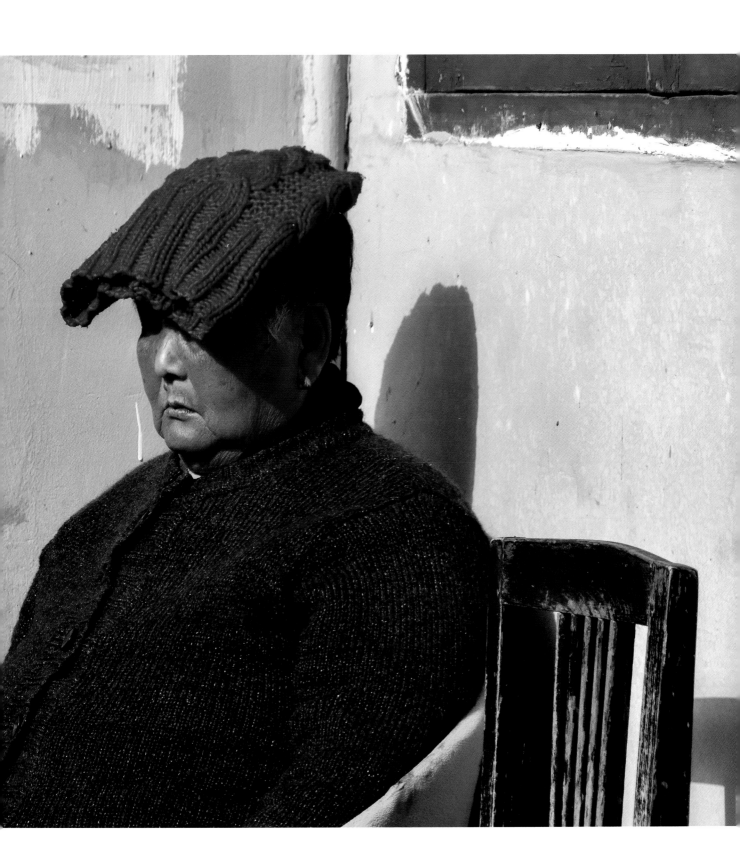

更多的阳光

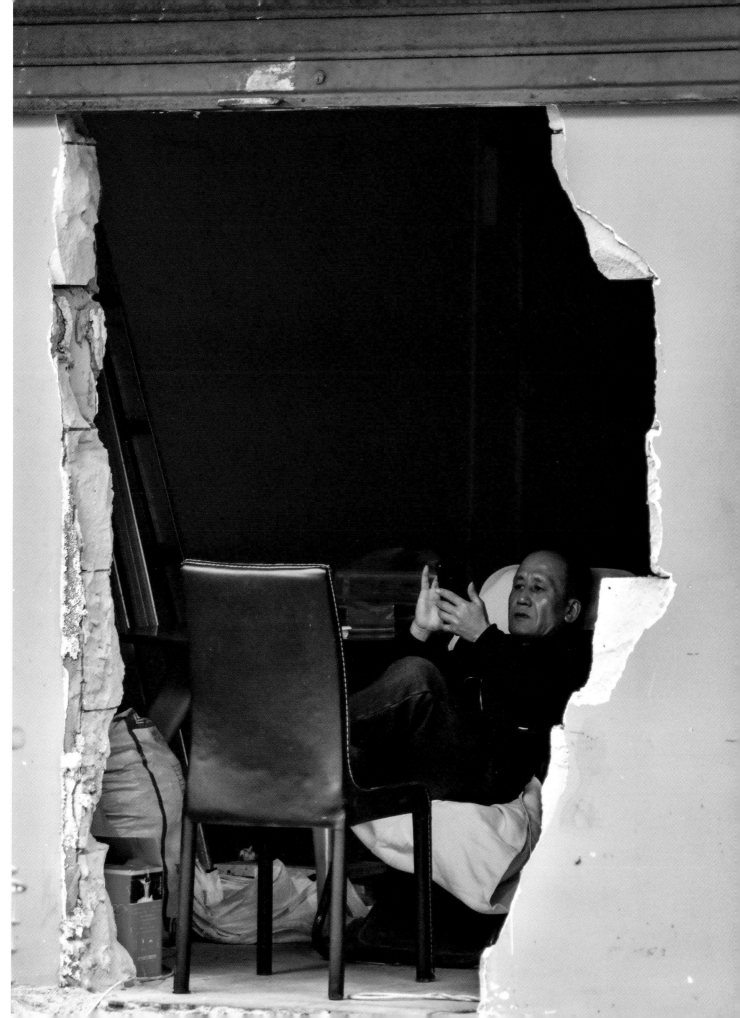

Four wheelin'

四轮

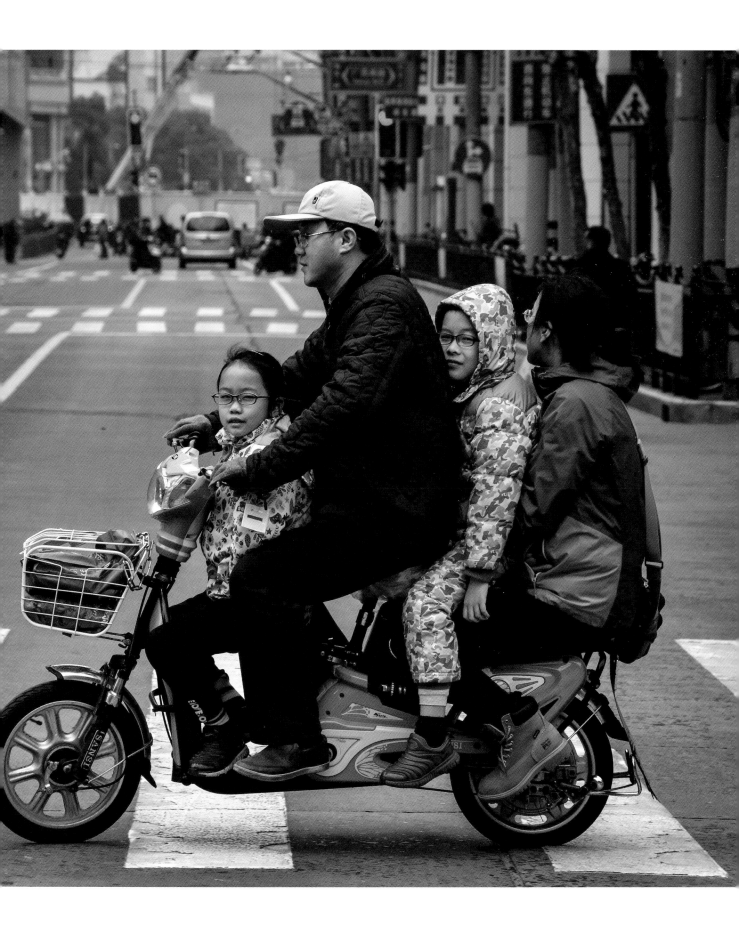

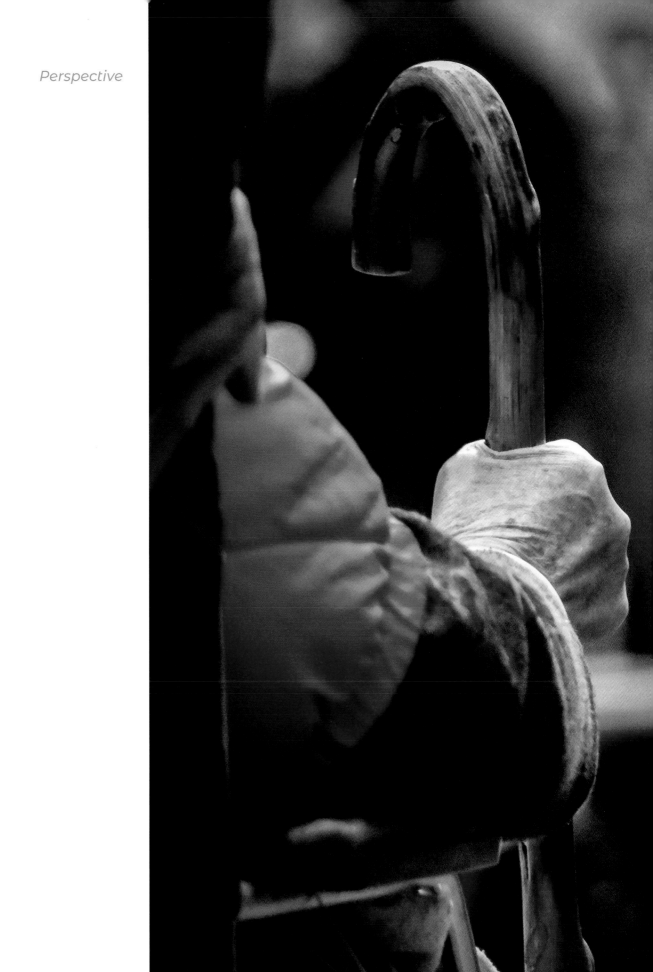

景

Ginger gets spicier with age

Chinese proverb

姜
还是
老的辣
中国谚语

Sneek a peek

偷窥

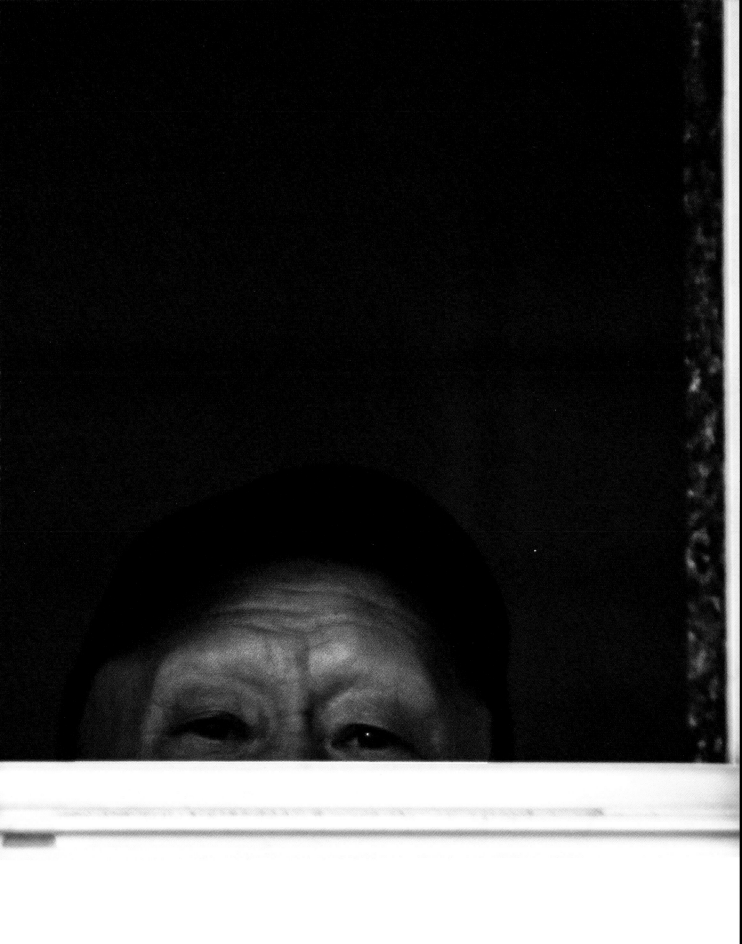

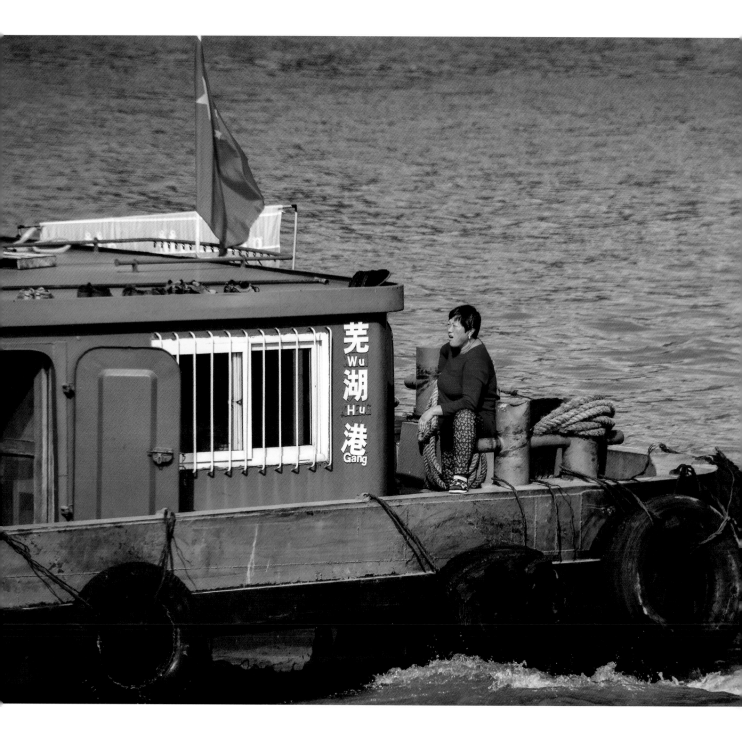

芜
Wu
湖
Hu
港
Gang

Huangpu River cruise

黄浦江漫游

厨师

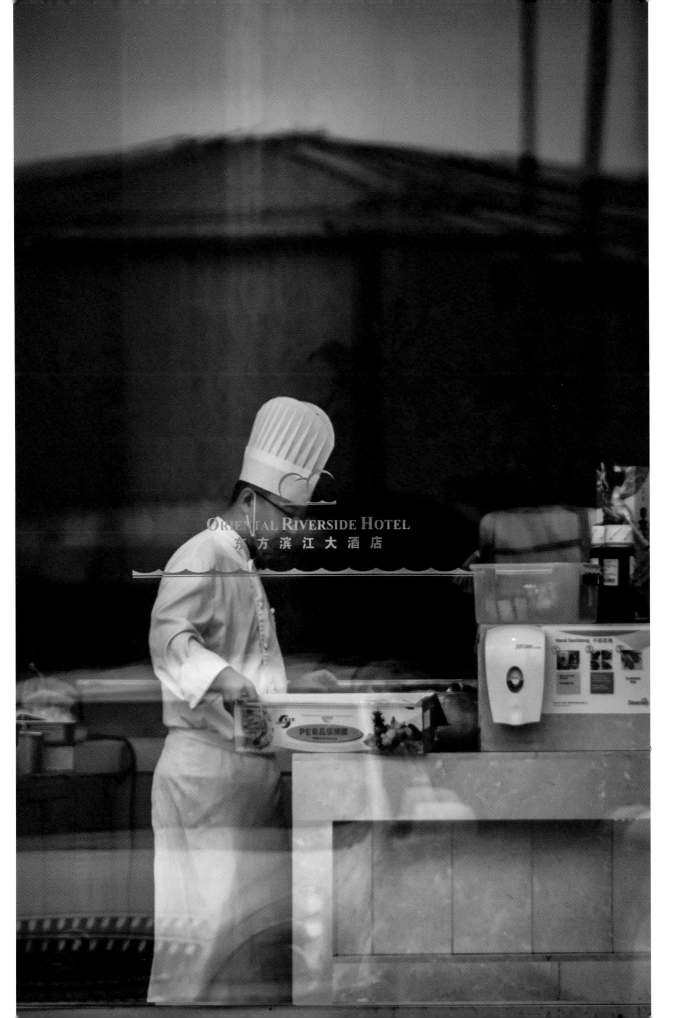

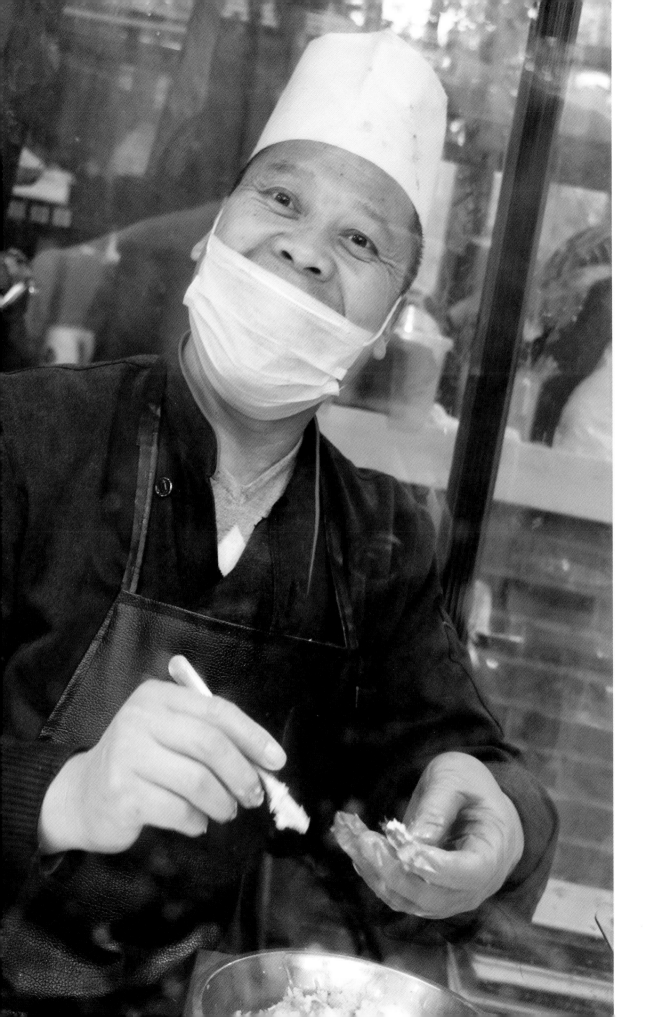

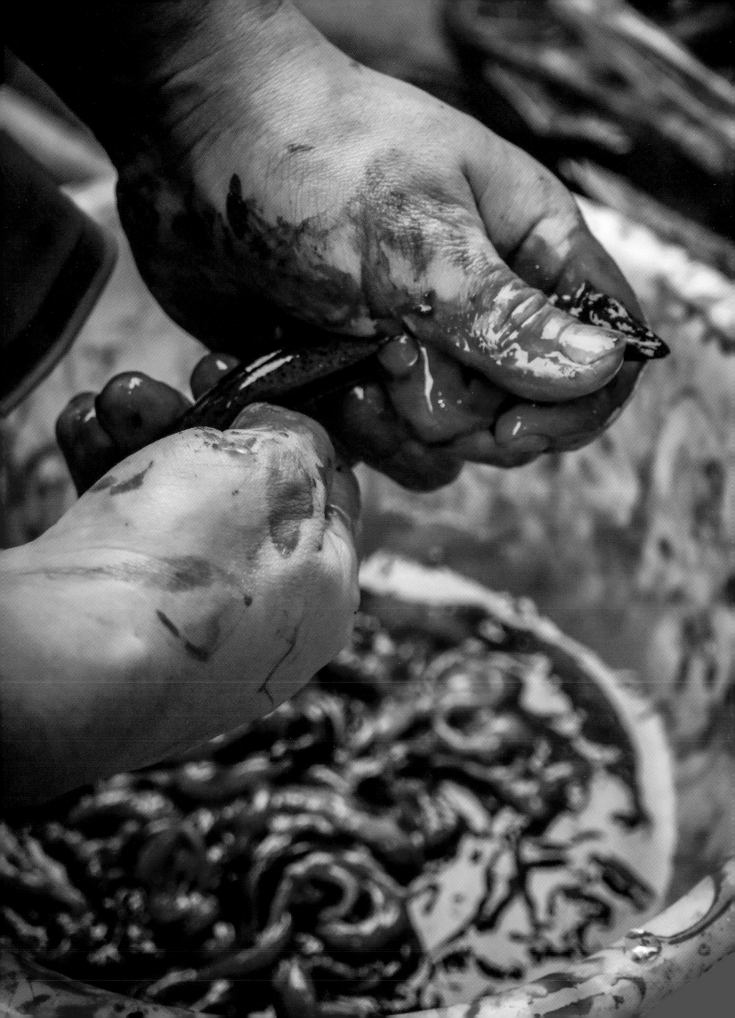

Seeing red

红色

Smells delicious

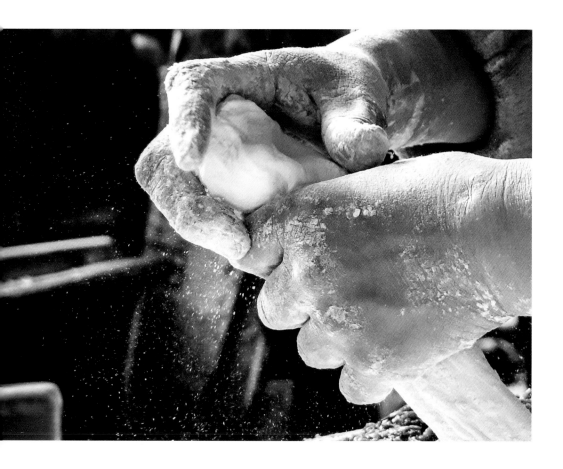

闻起来很美味

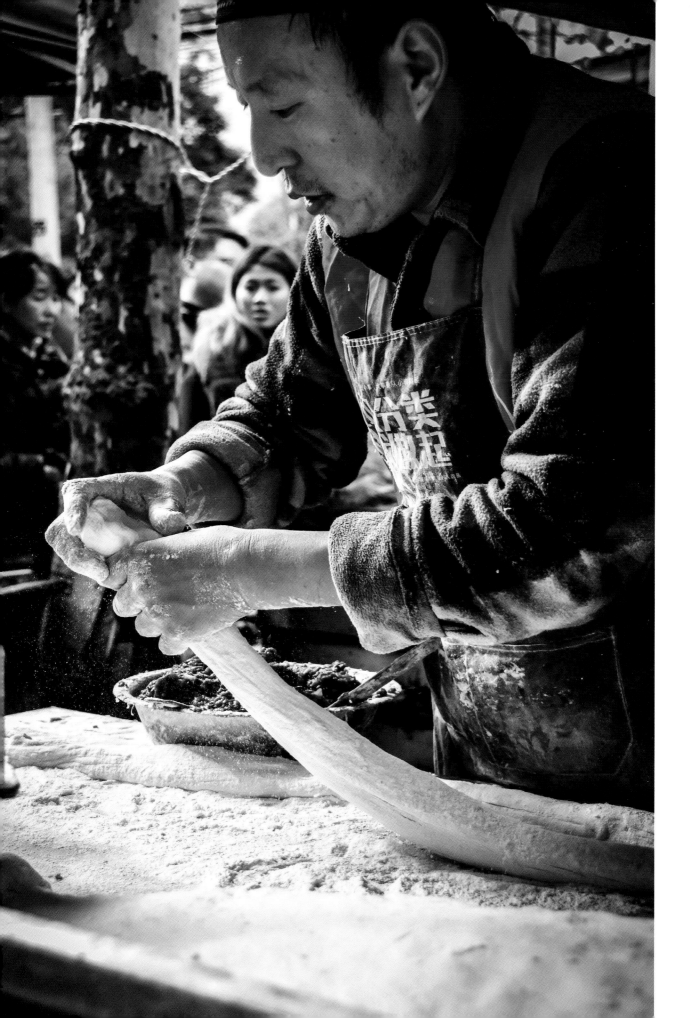

给予比
接受
更幸福
圣经

There is more
happiness
in giving
than there is
in receiving

The Bible

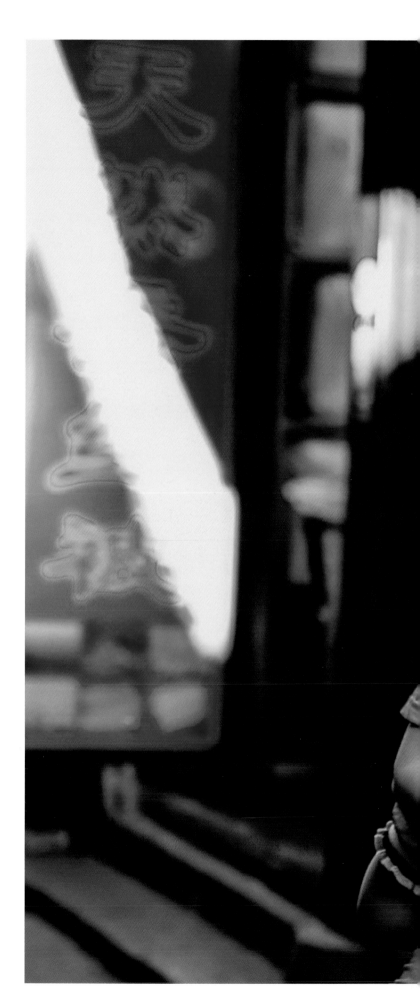

Safe

安全

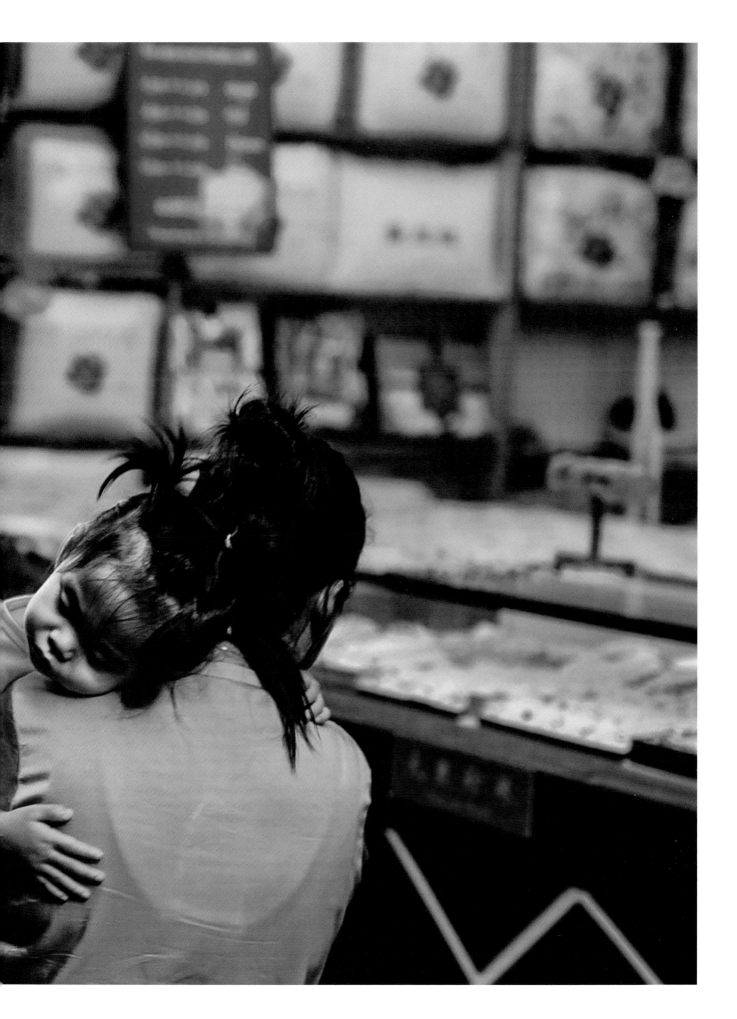

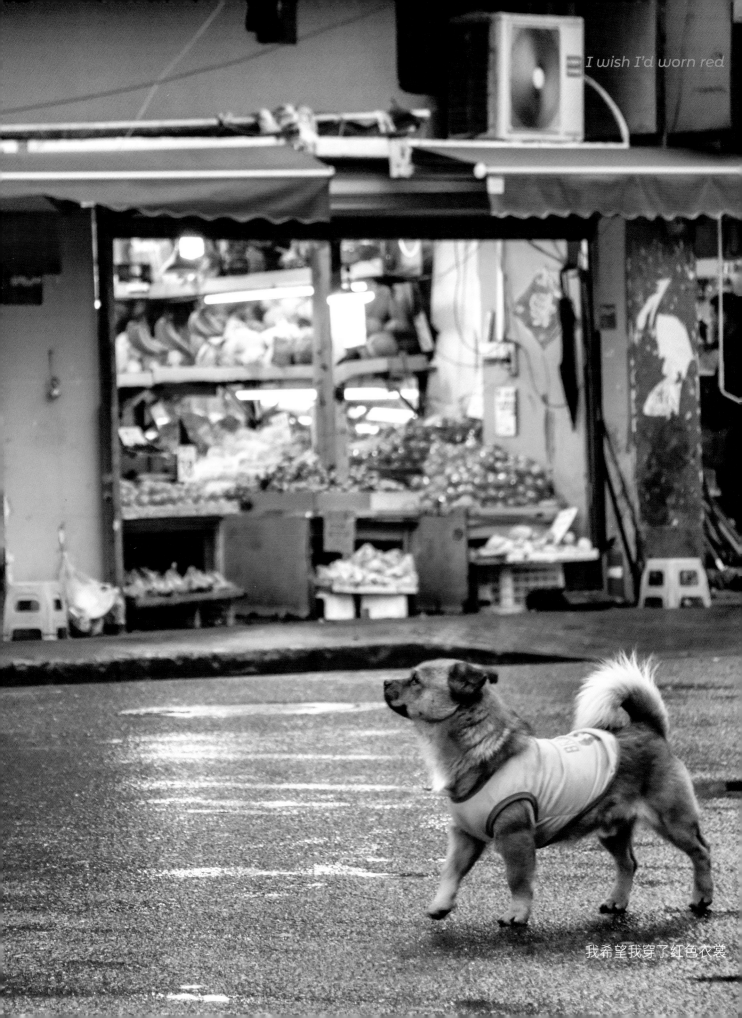

I wish I'd worn red

我希望我穿了红色衣裳
I wish I'd worn red

3，2，1，跳

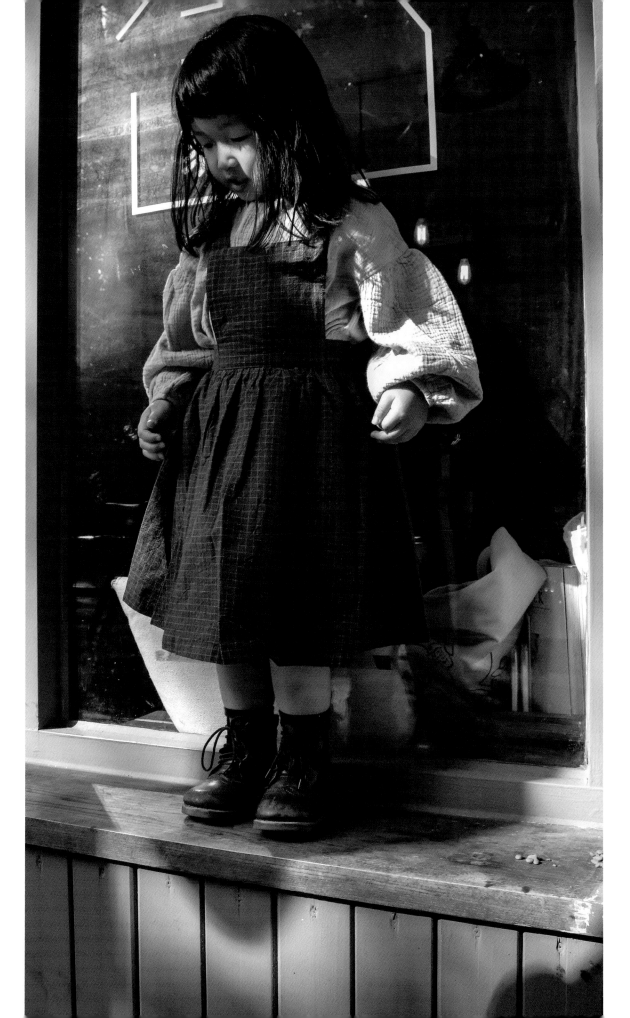

Ray of light

光线

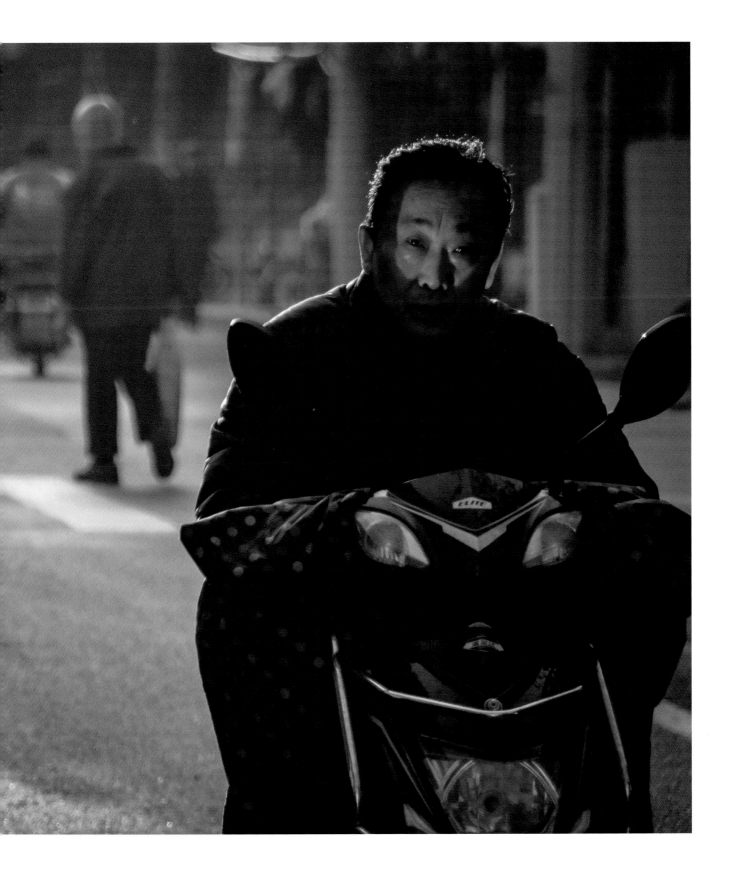

好朋友

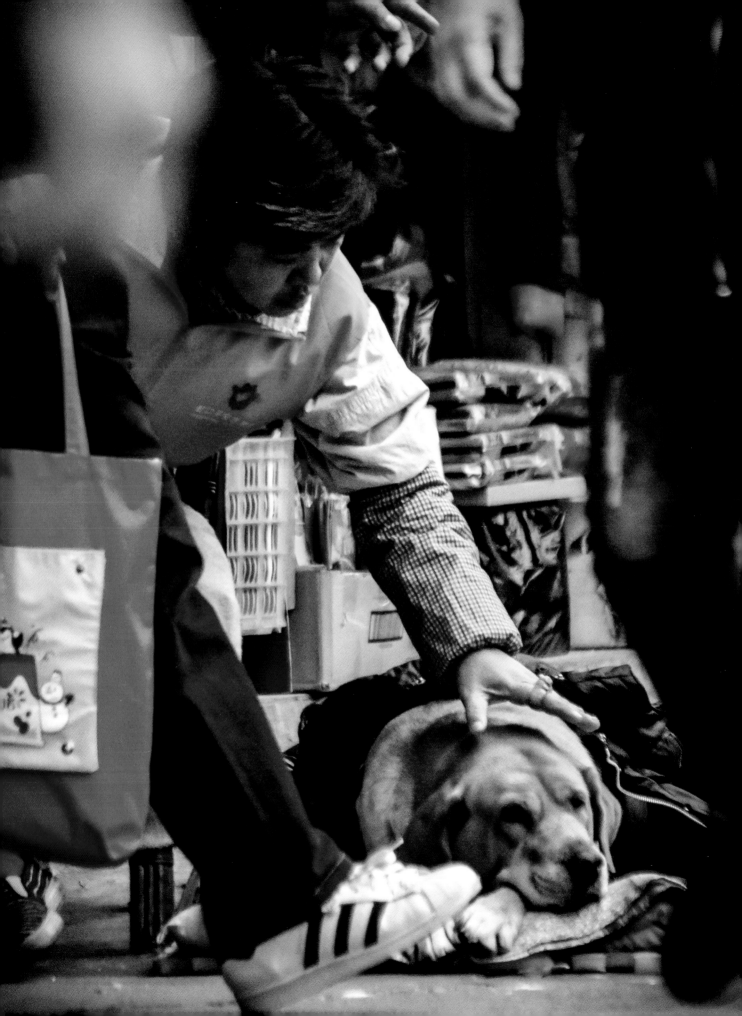

True beauty
doesn't ask for
attention

你若盛开
蝴蝶自来

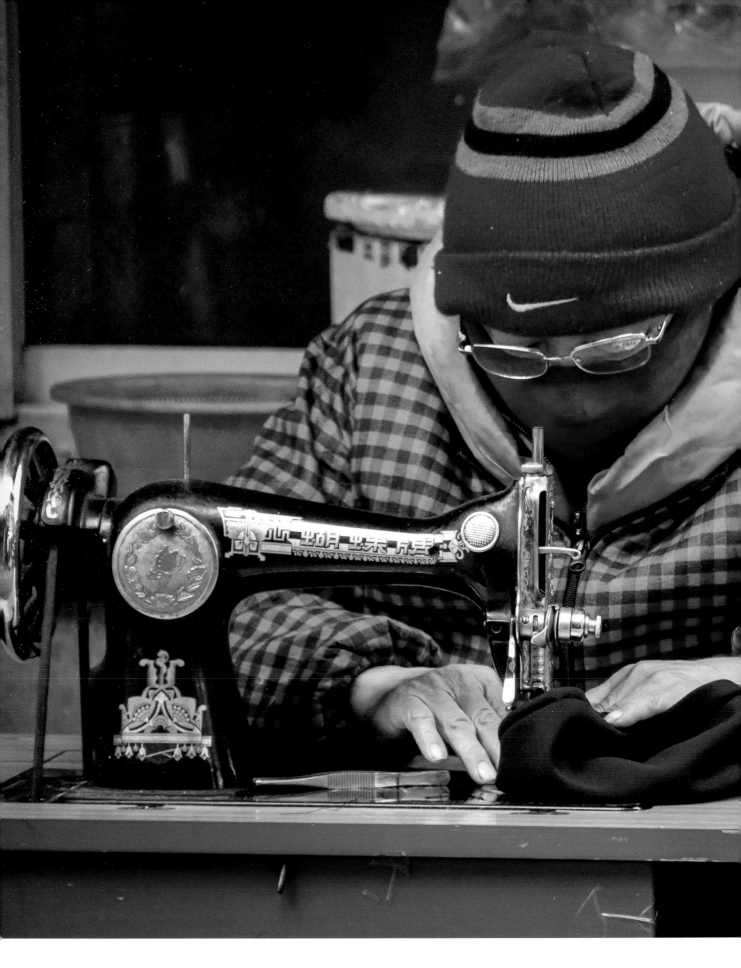

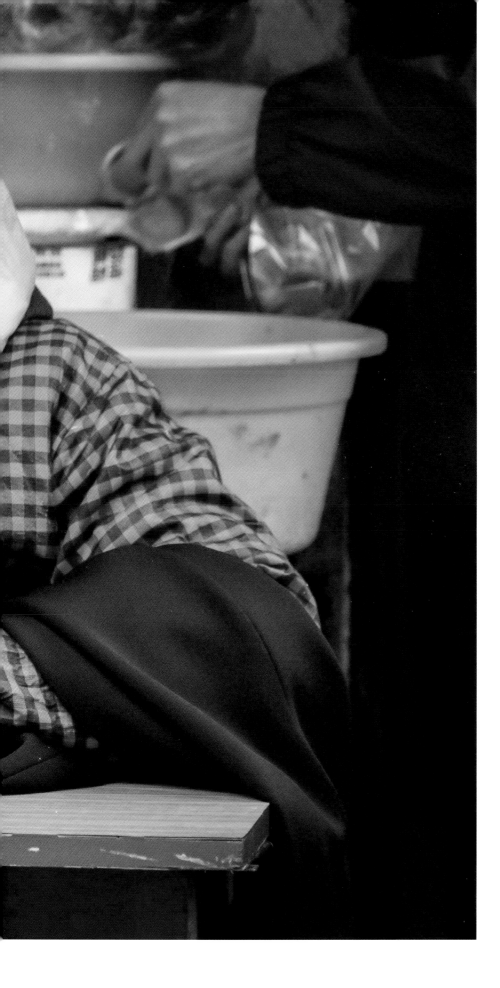

手工艺人

Barber bun

理发师

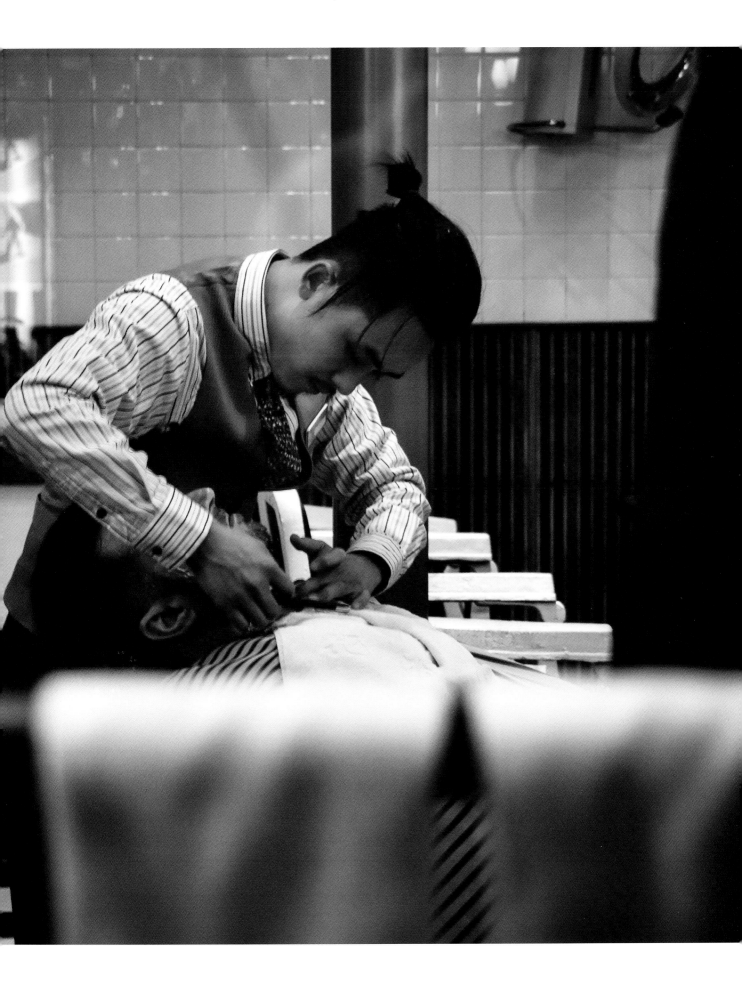

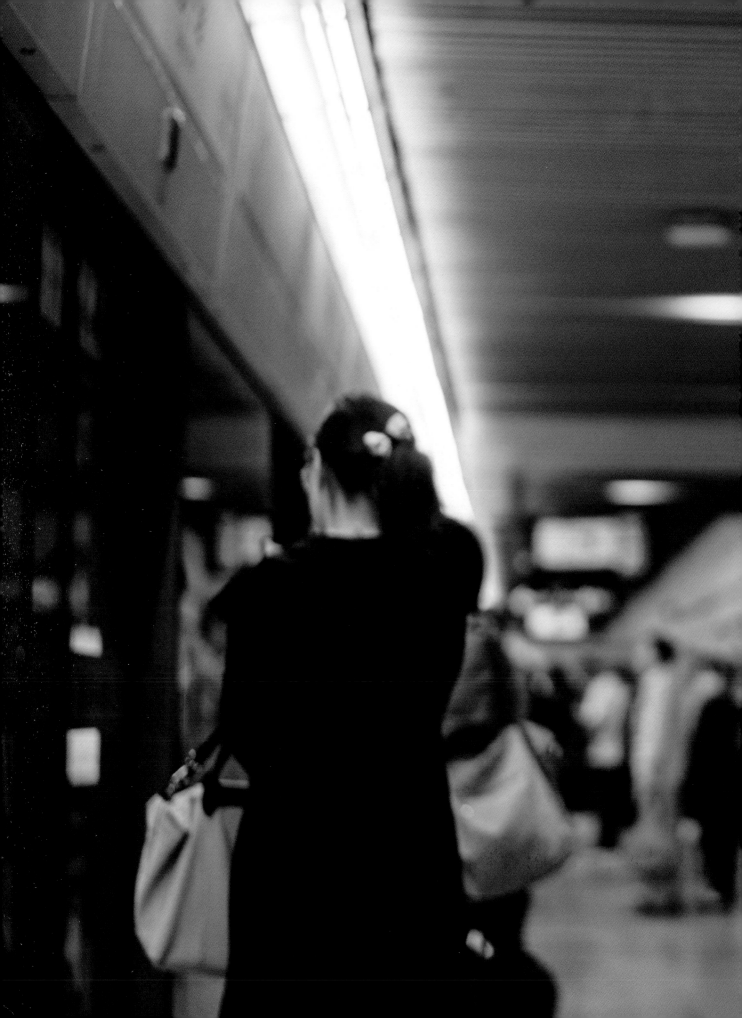

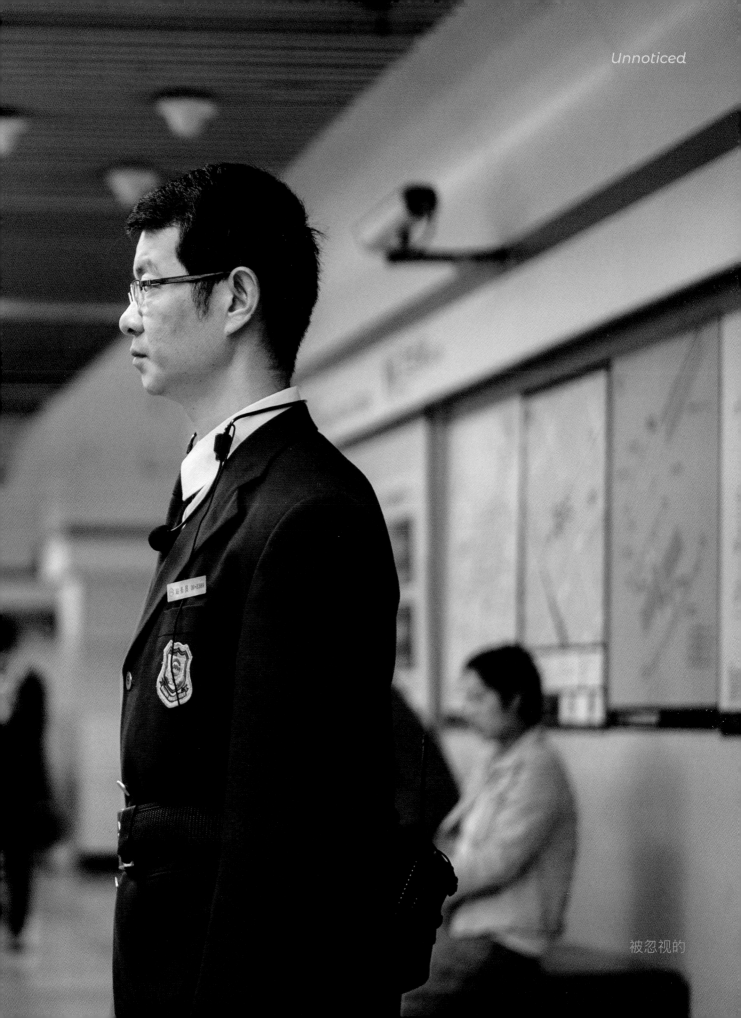

Unnoticed

被忽视的

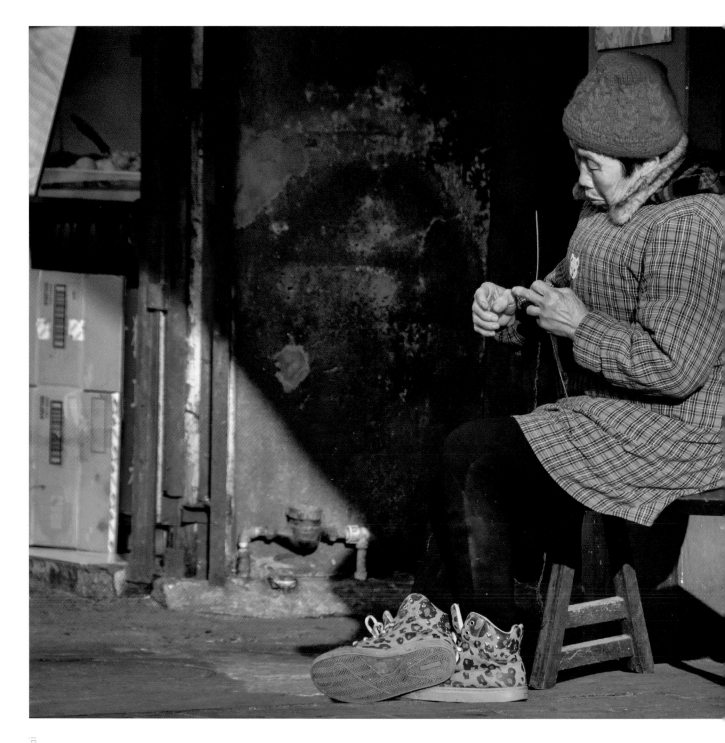

new shoes

新鞋

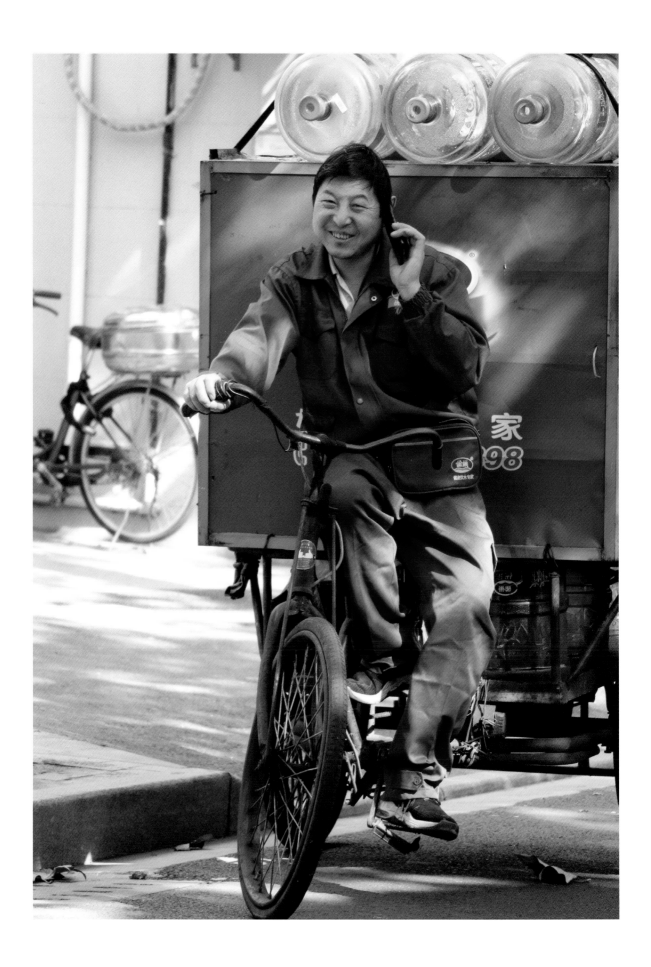

We're having twins!

我们有双胞胎了！

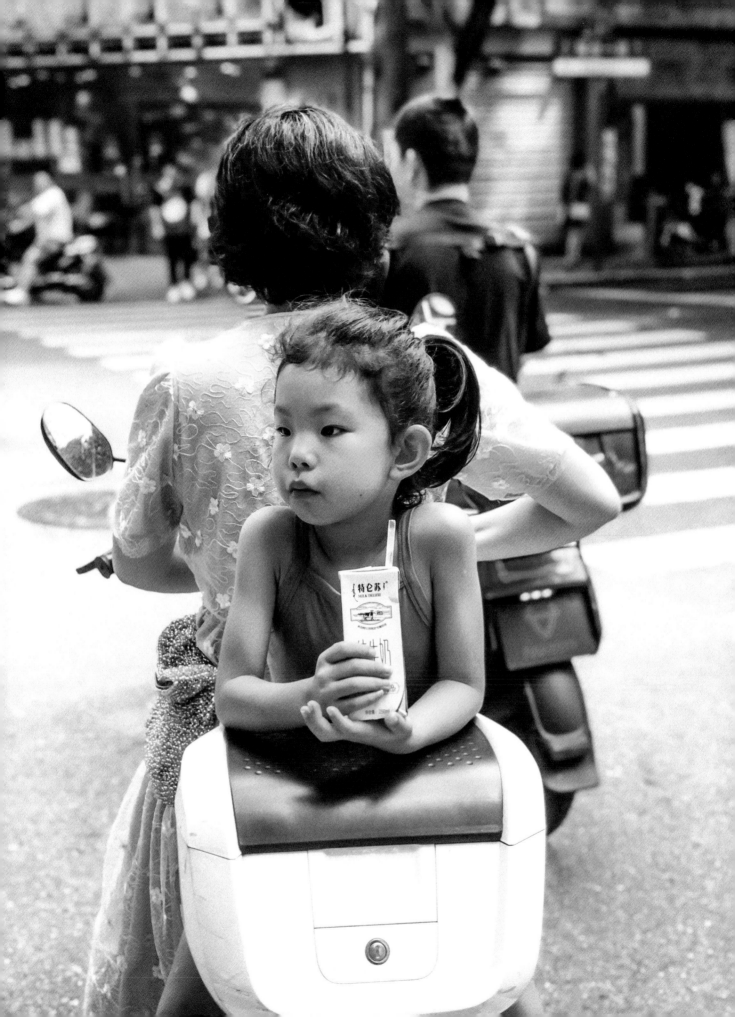

Milking it!

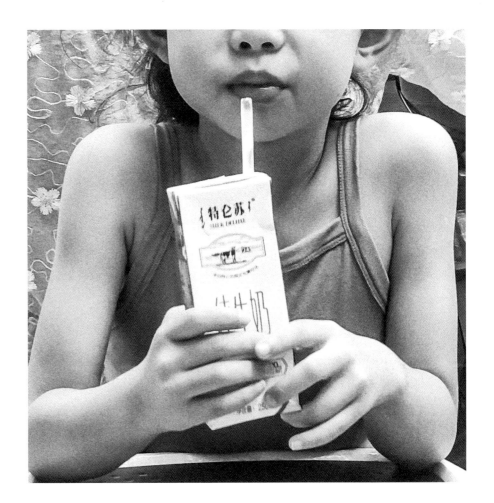

喝奶

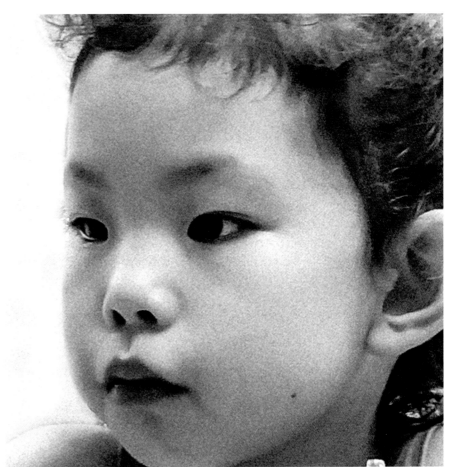

辛勤劳作
终有报
圣经

The work of
his hands
will reward him

The Bible

外滩后台

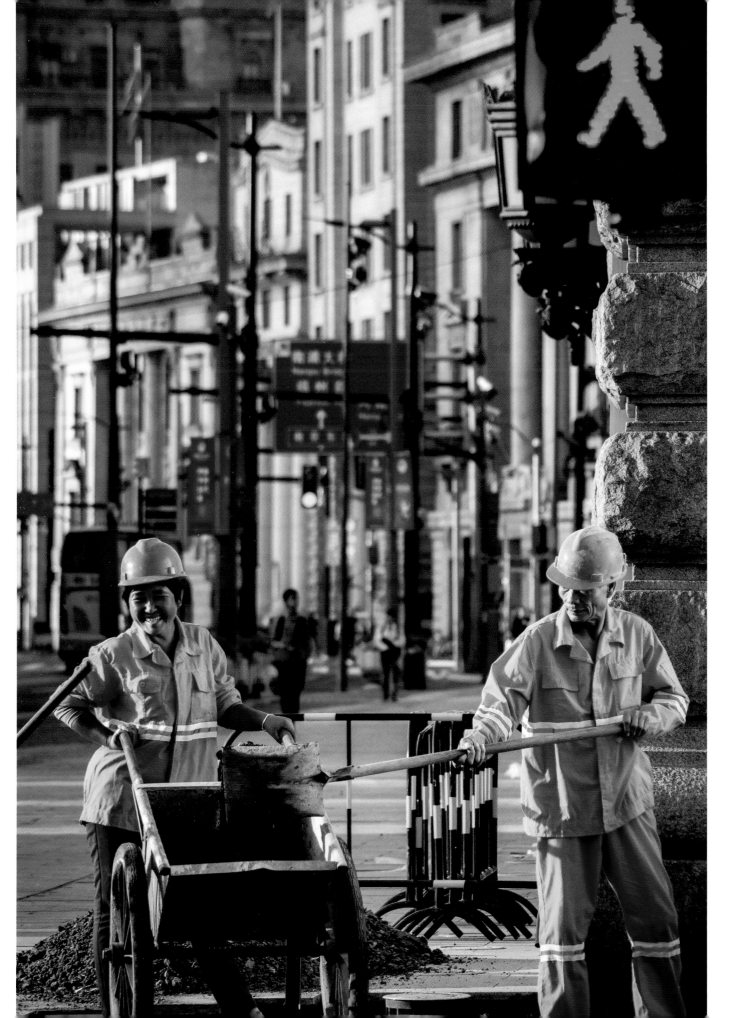

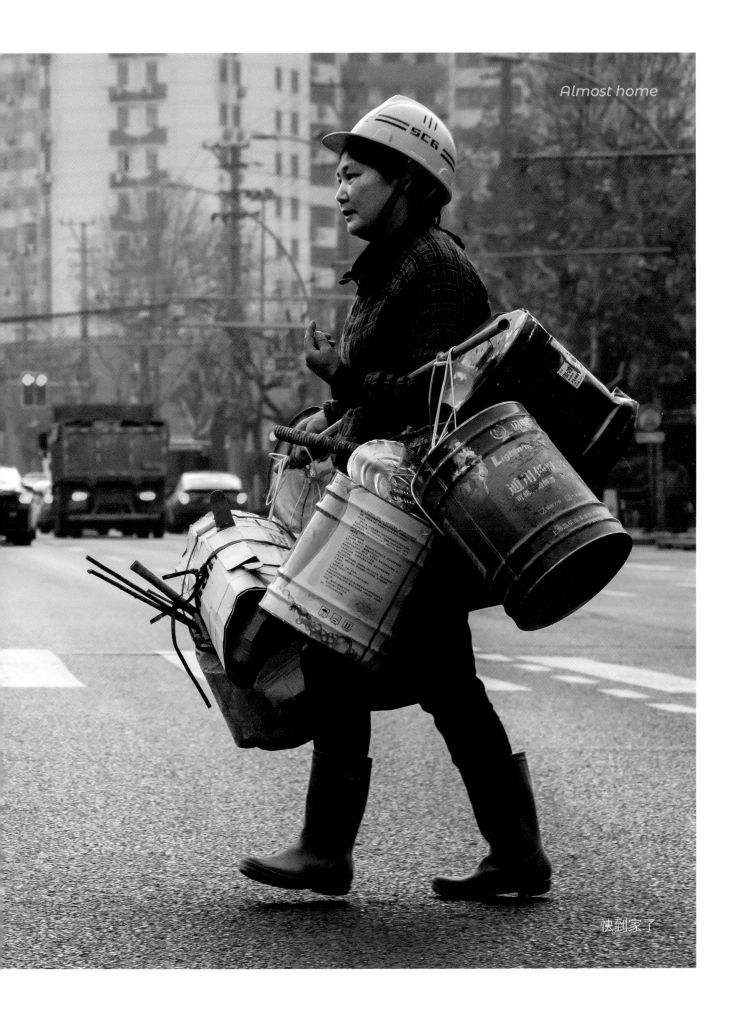

快到家了

2 Wheels

2个轮子

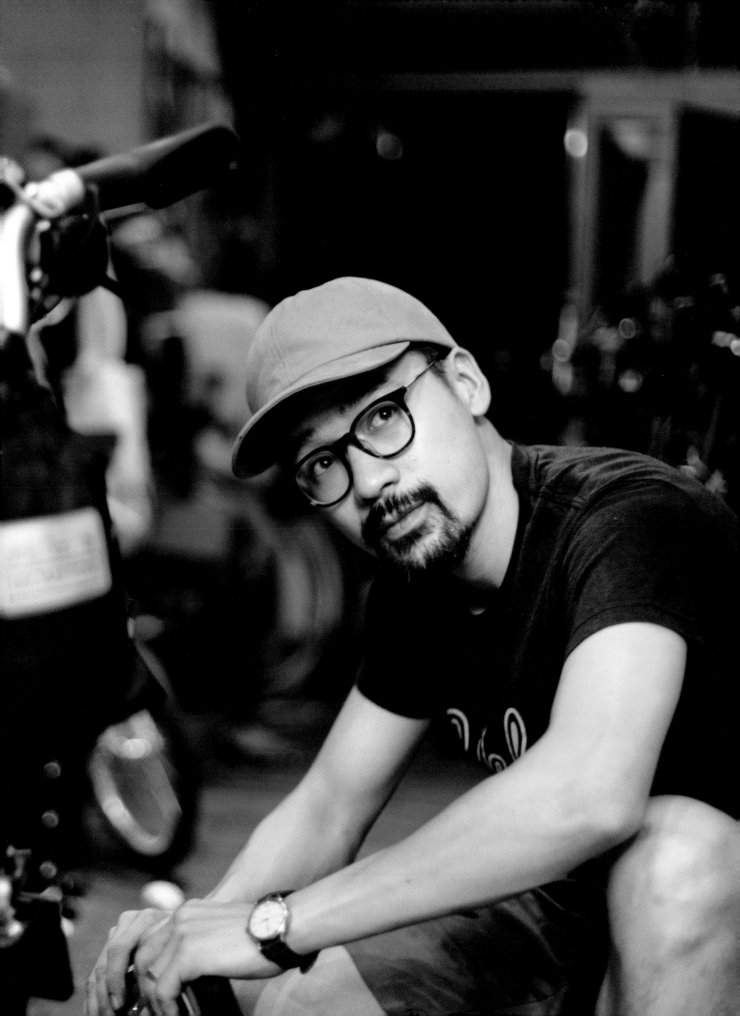

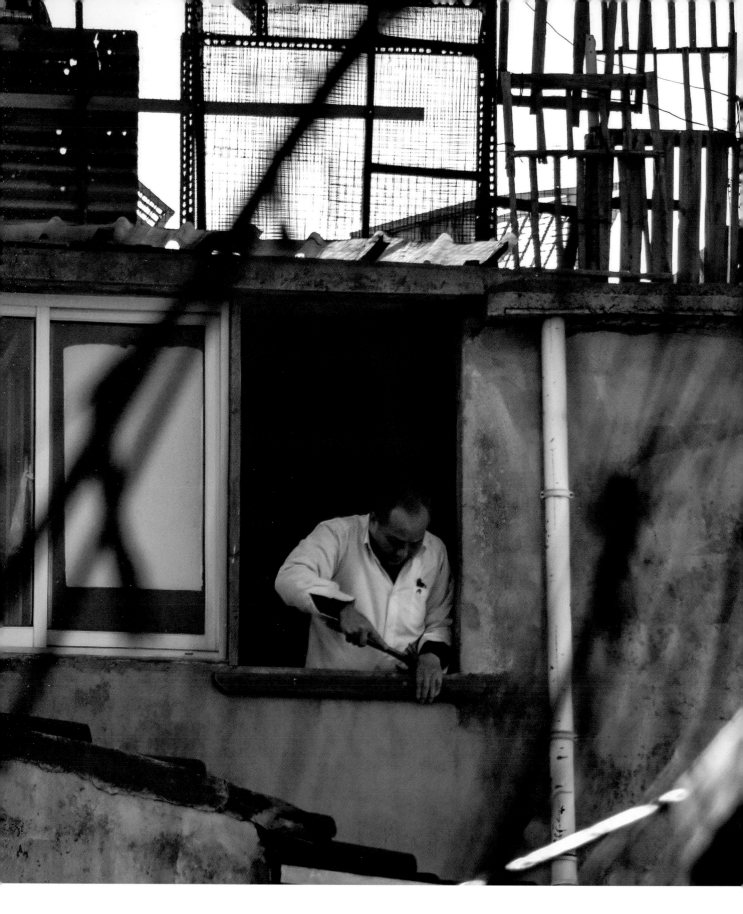

维修工

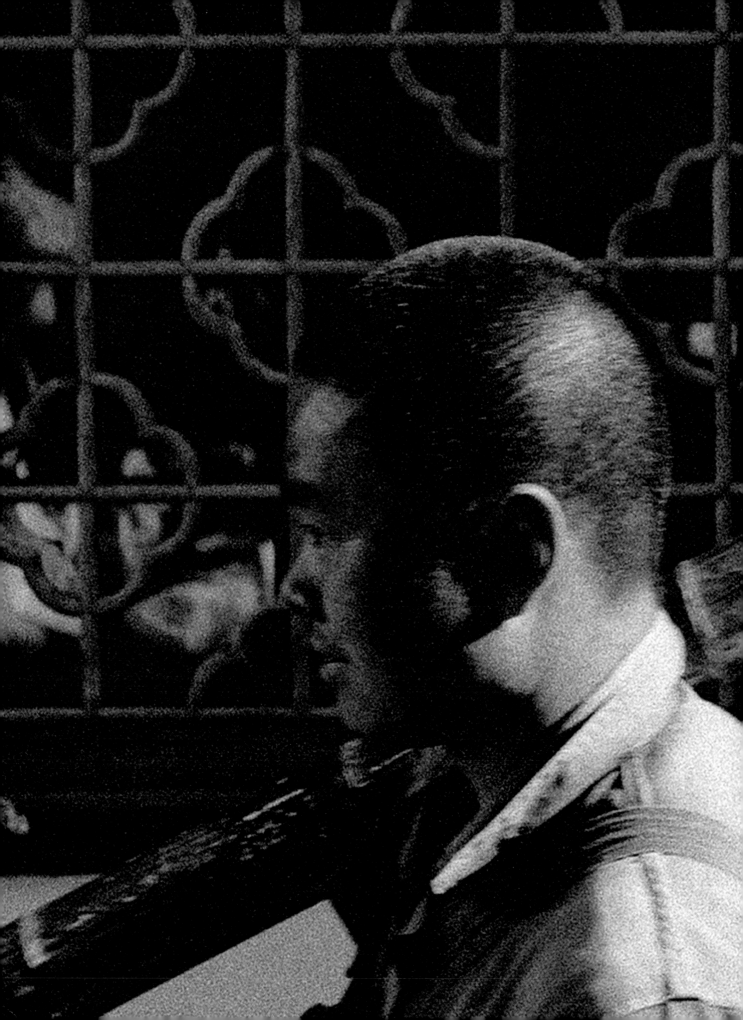

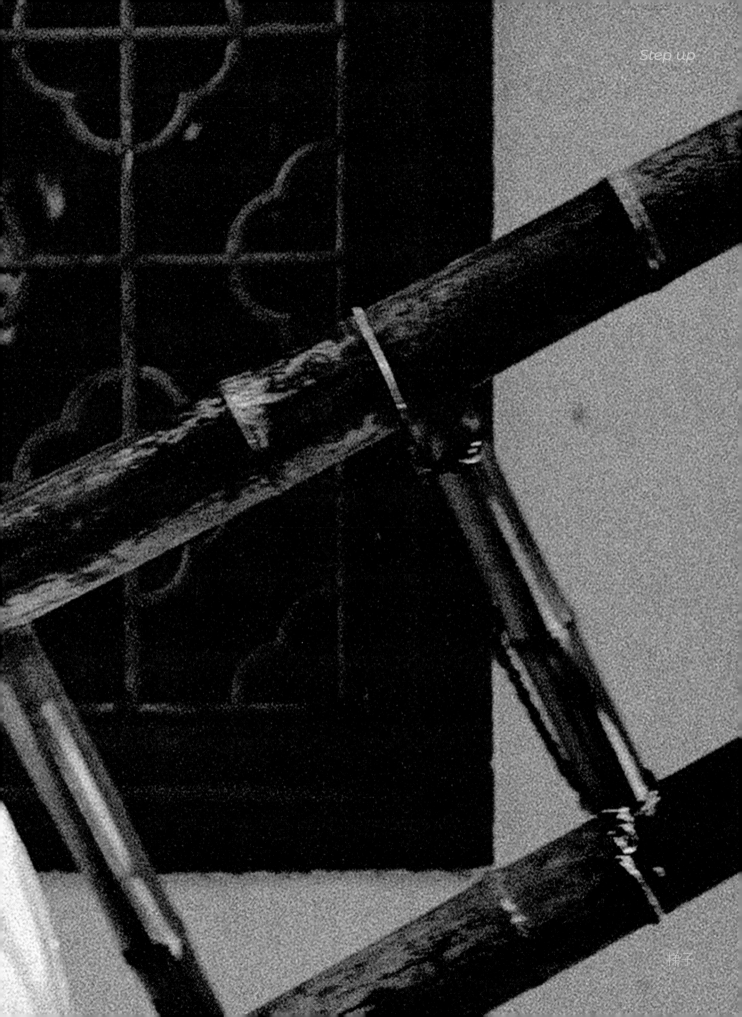

Step up

梯子
Step up

阴影下的微笑

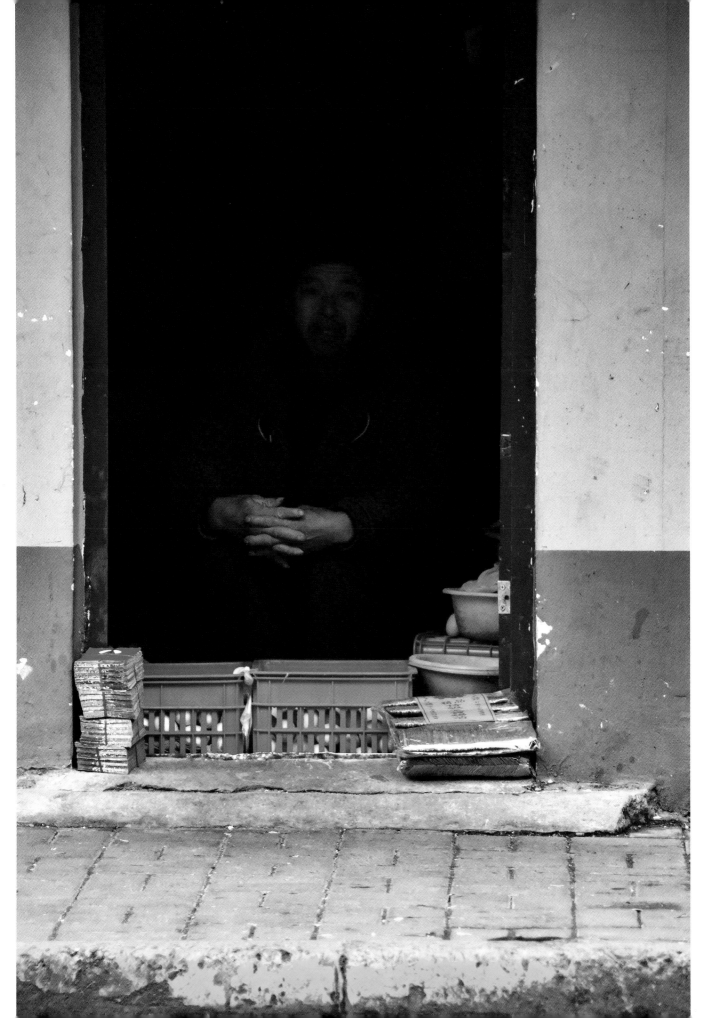

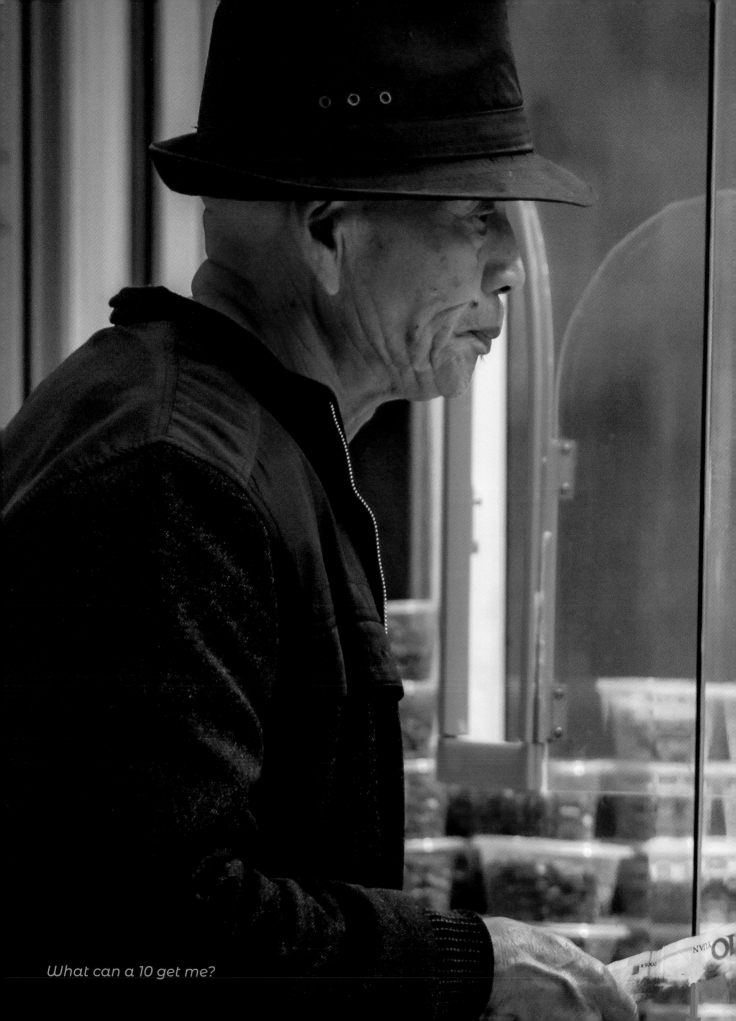

What can a 10 get me?

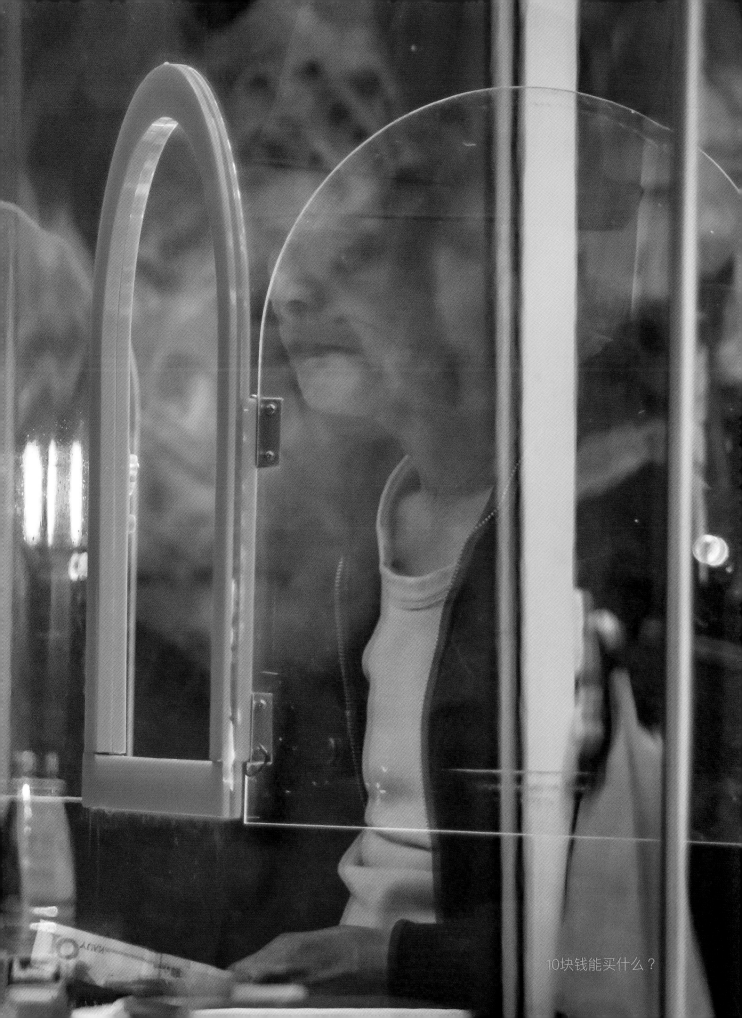

10块钱能买什么？

微笑是一种语言

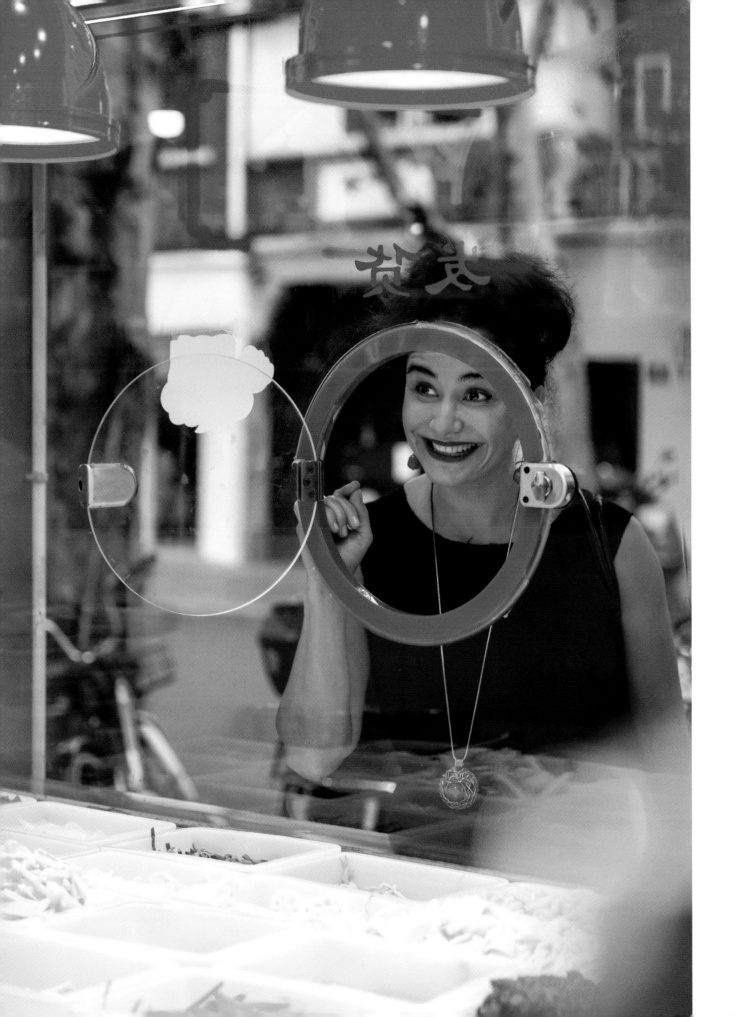

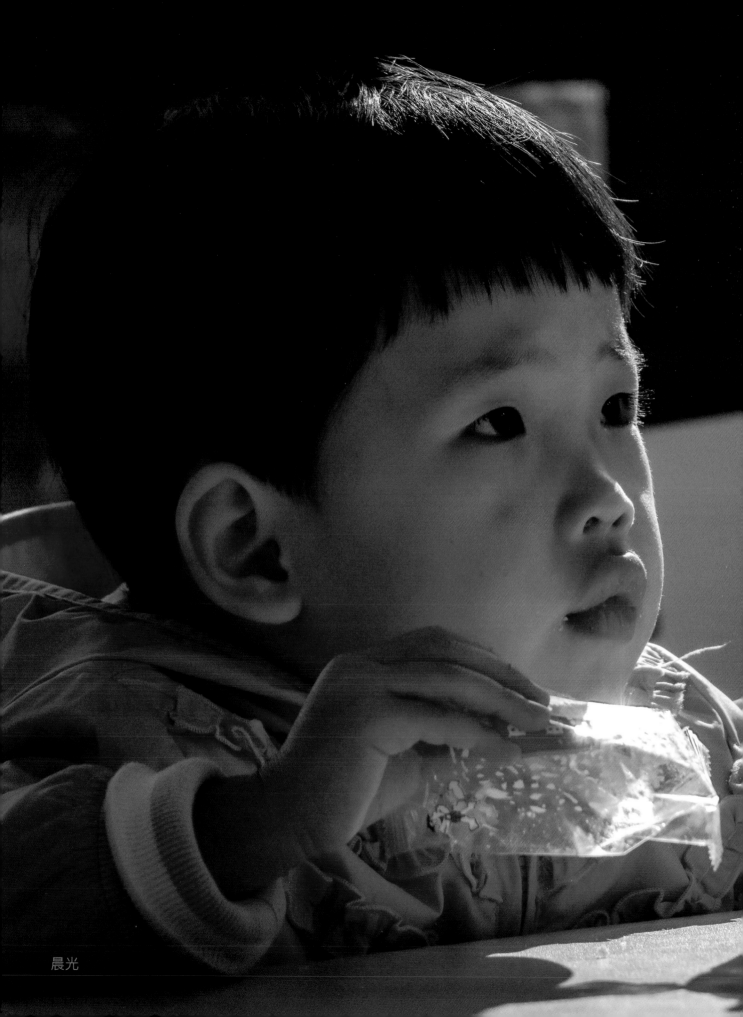

晨光

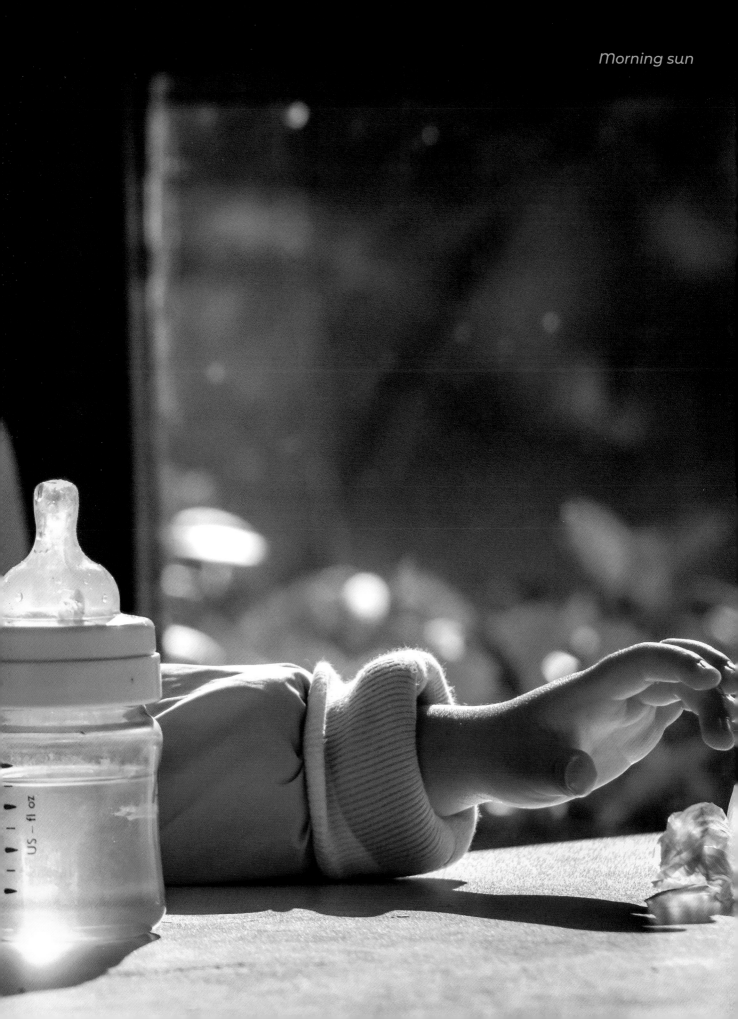

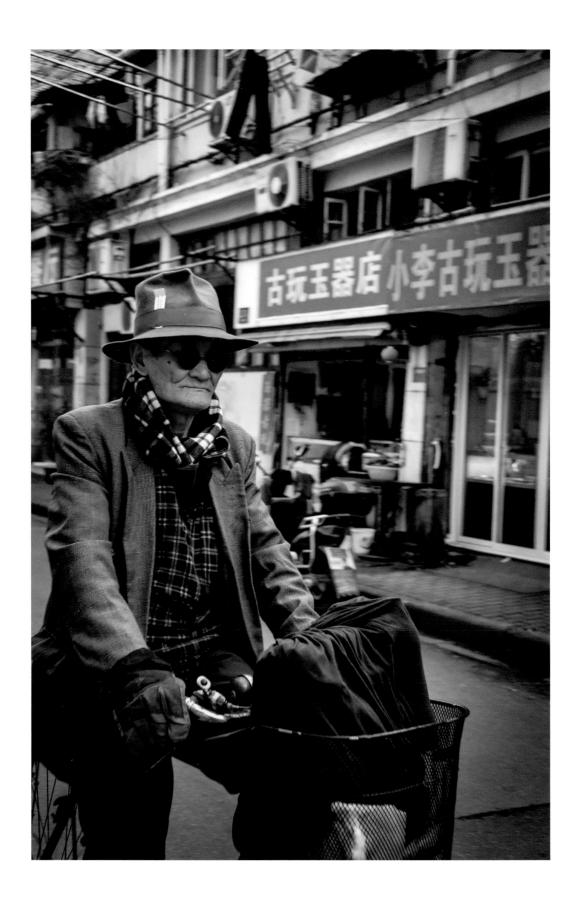

still pedalin'

继续前行

All things change
and we change
with them
Chinese proverb

物是人非
事事非
中国谚语

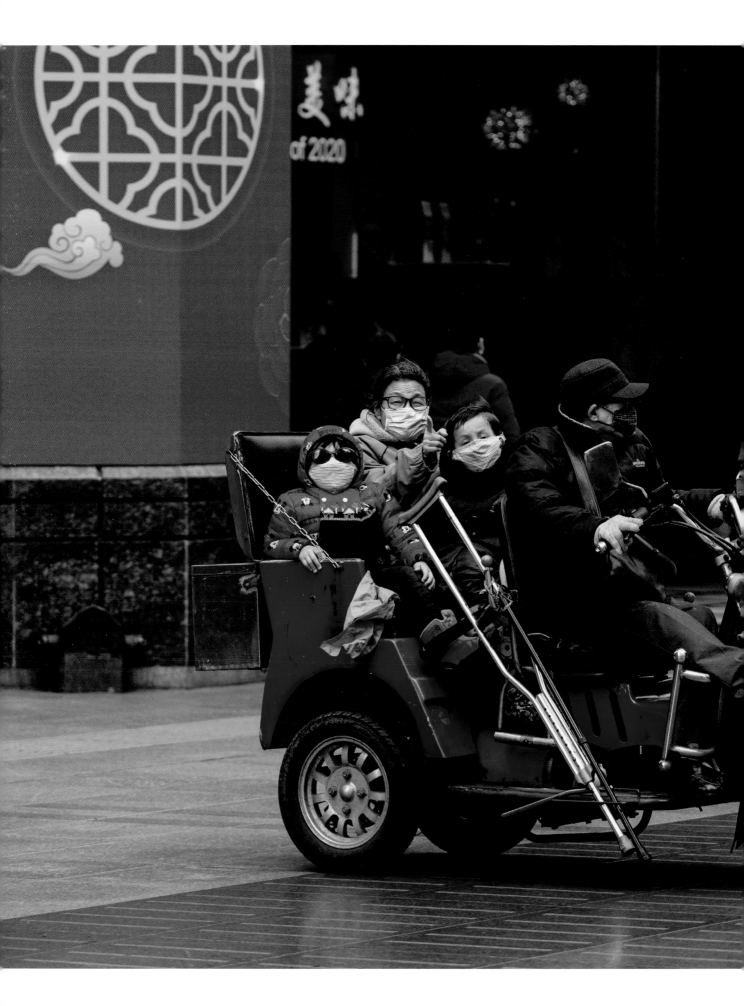

Finally out

出行

My superhero

我的超级英雄

Love looks for a way

爱试着找到方法

闺蜜时光

A walk in the park

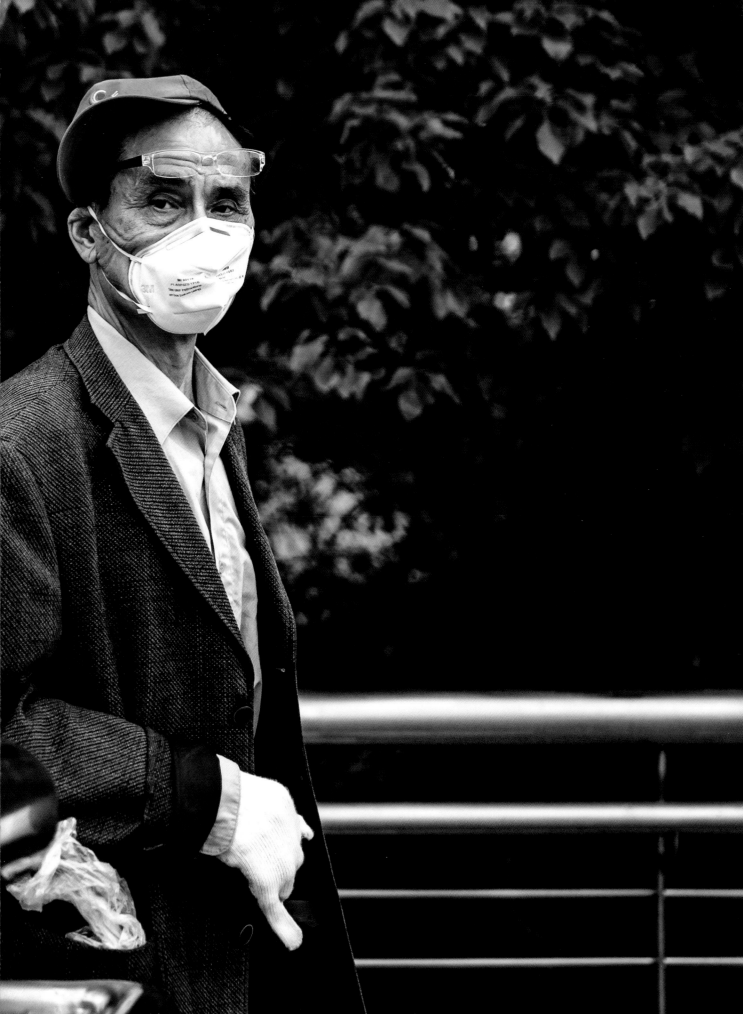

Forgot my lipstick

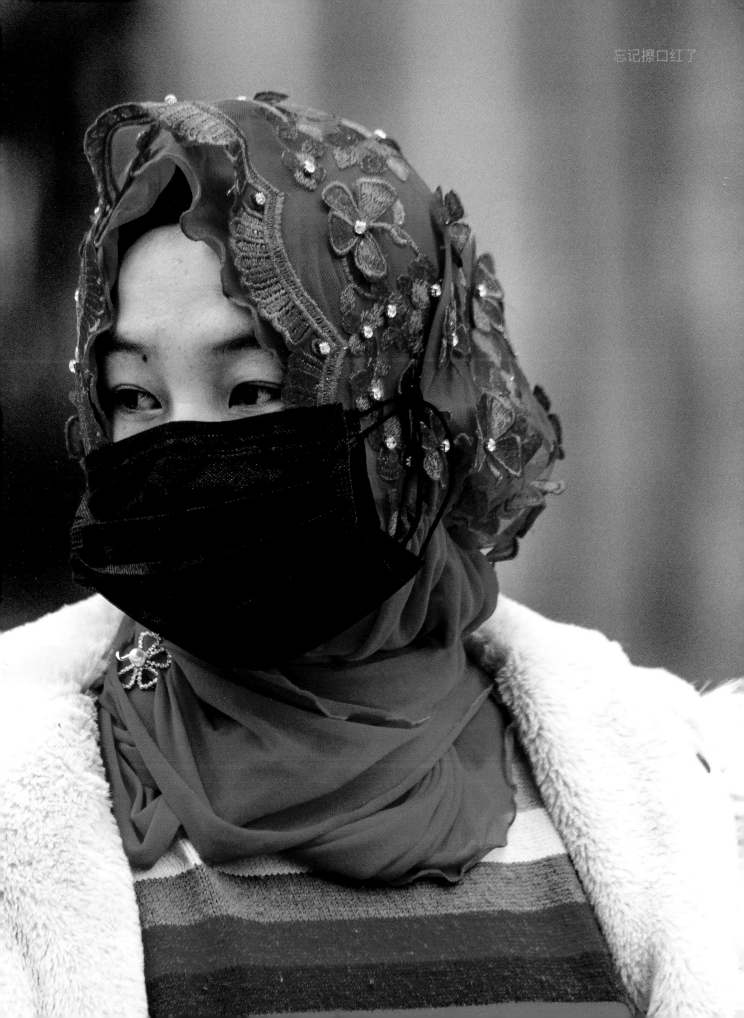

忘记擦口红了

最爱游乐场

I'm still playing

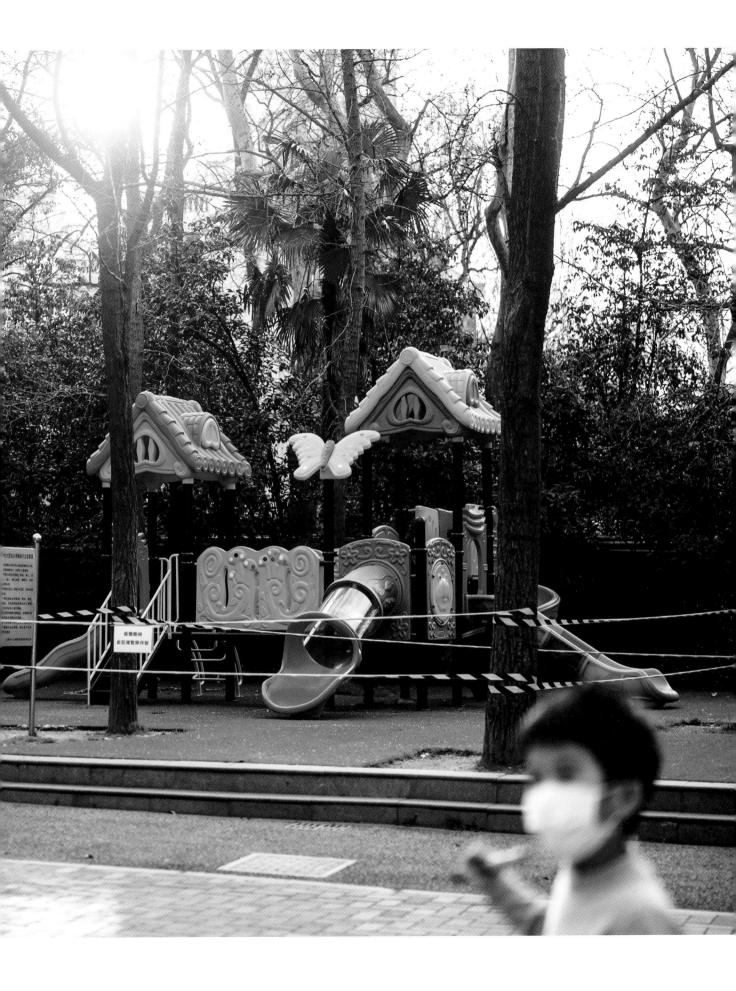

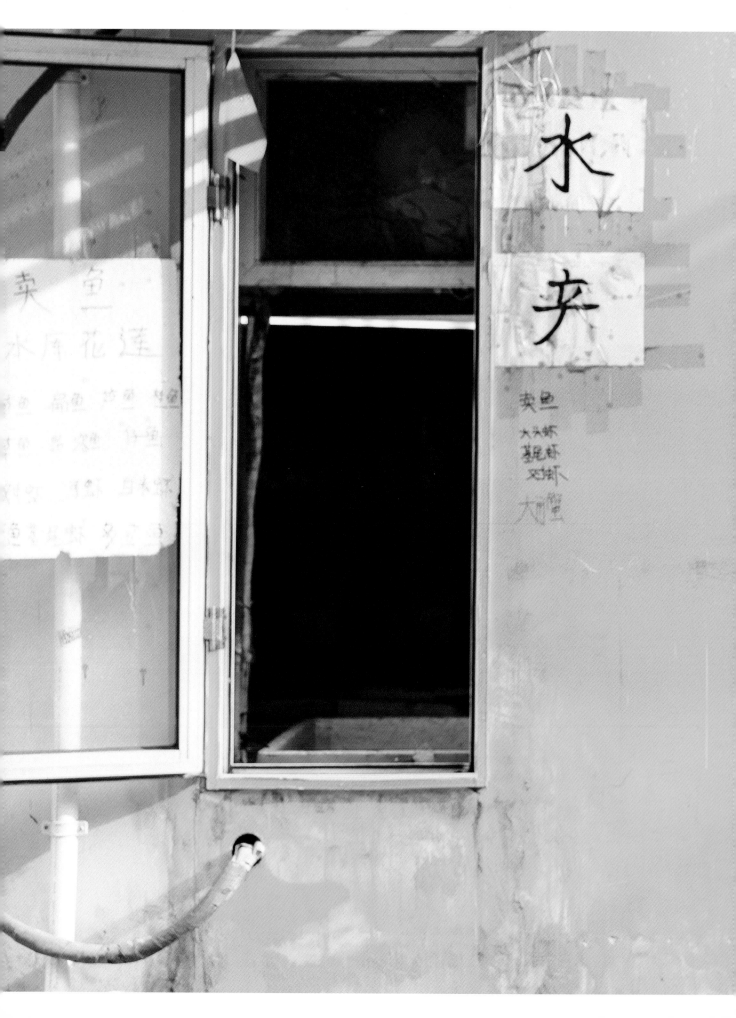

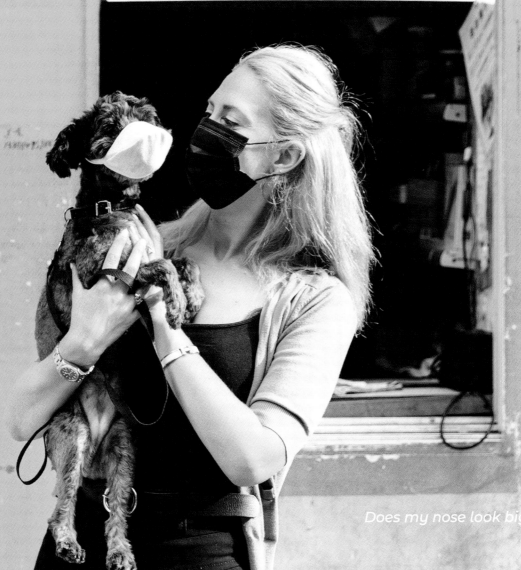

Does my nose look big in this?

戴着口罩我鼻子看起来

勿以往之不谏
知来者之可追

The best time
to plant a tree
was twenty years ago.
The second best time
is today

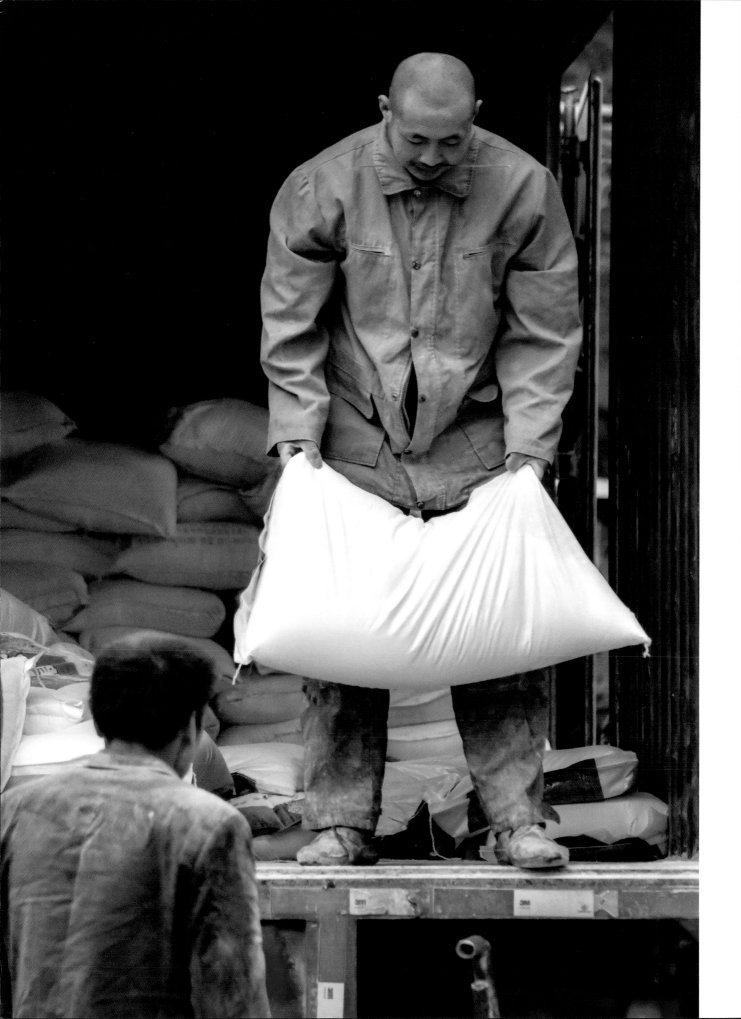

Strength

力量

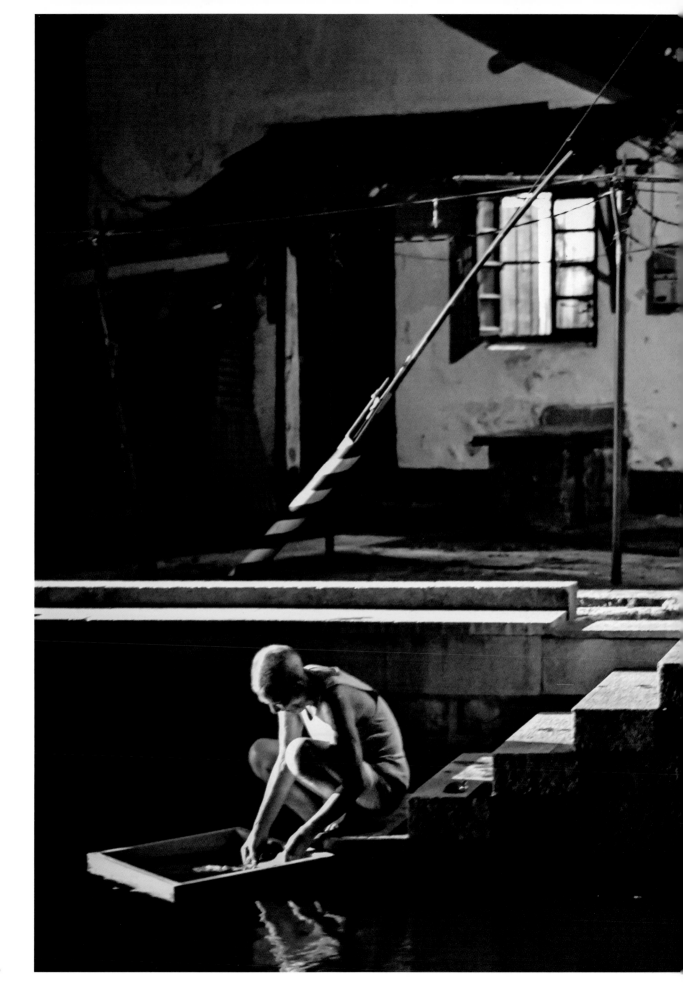

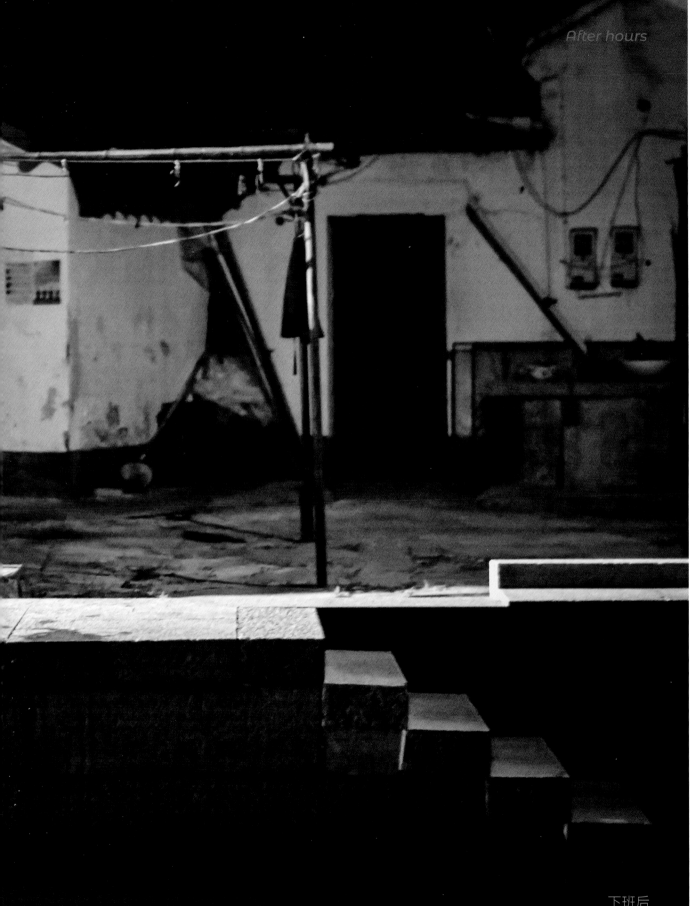

下班后

东方明珠塔

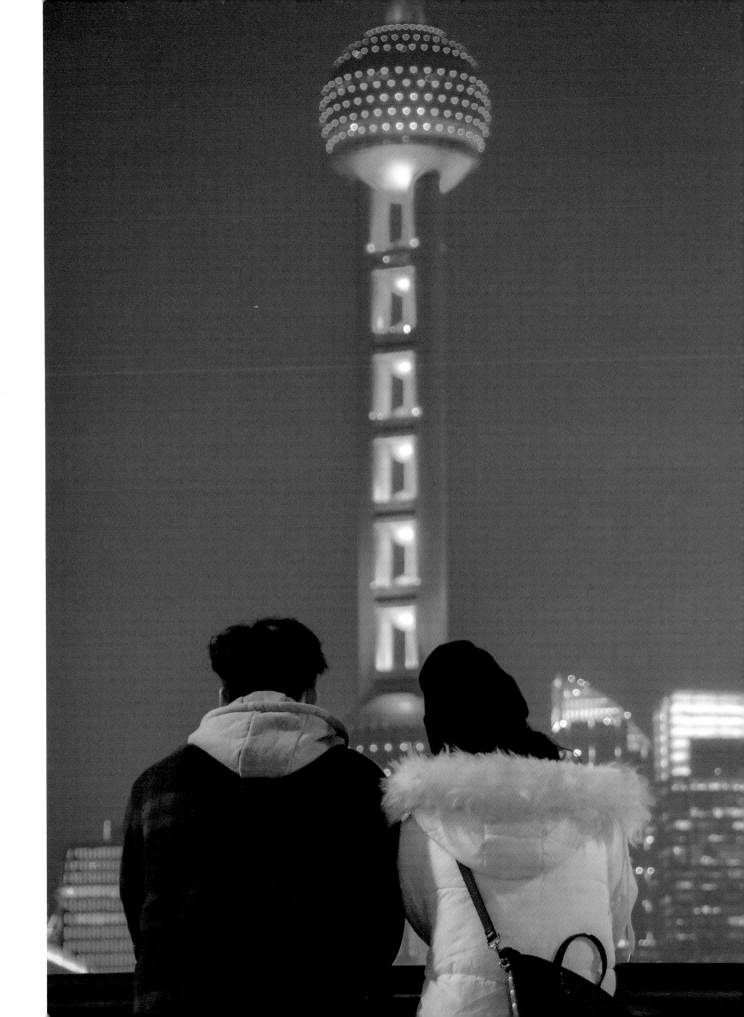

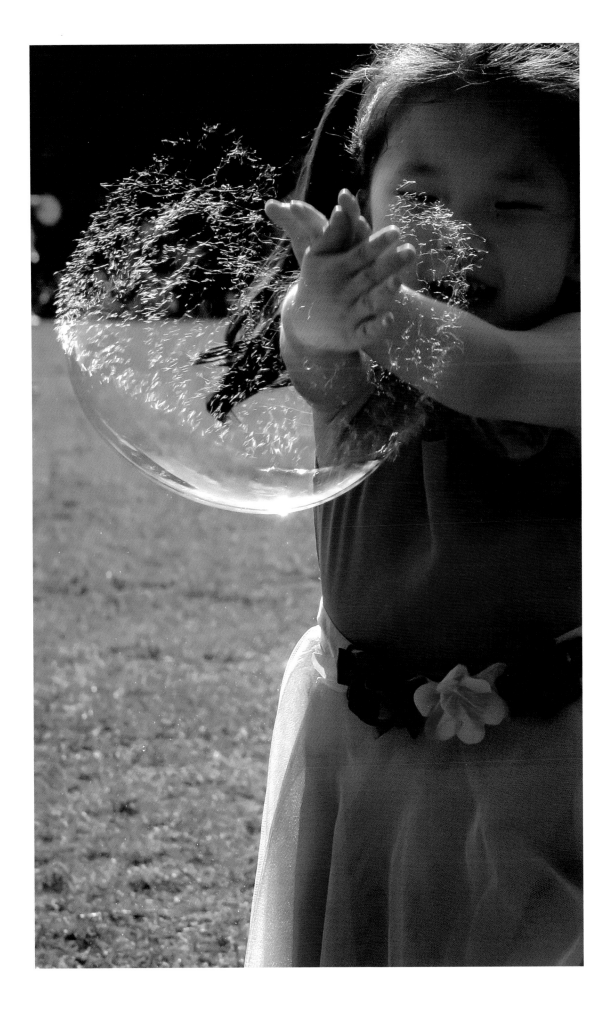

微笑

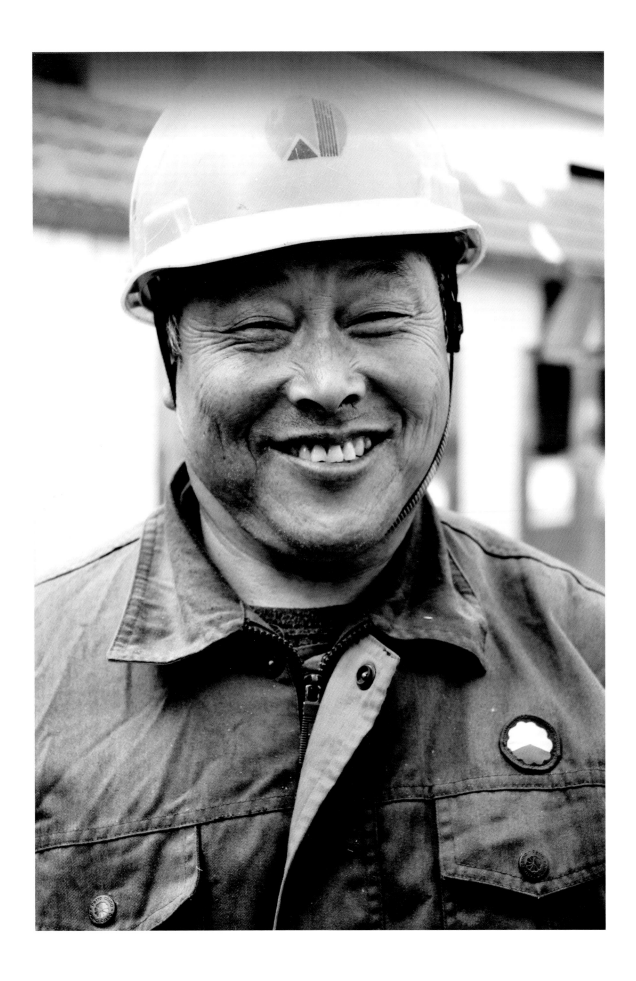

My lane

我的弄堂

My lane

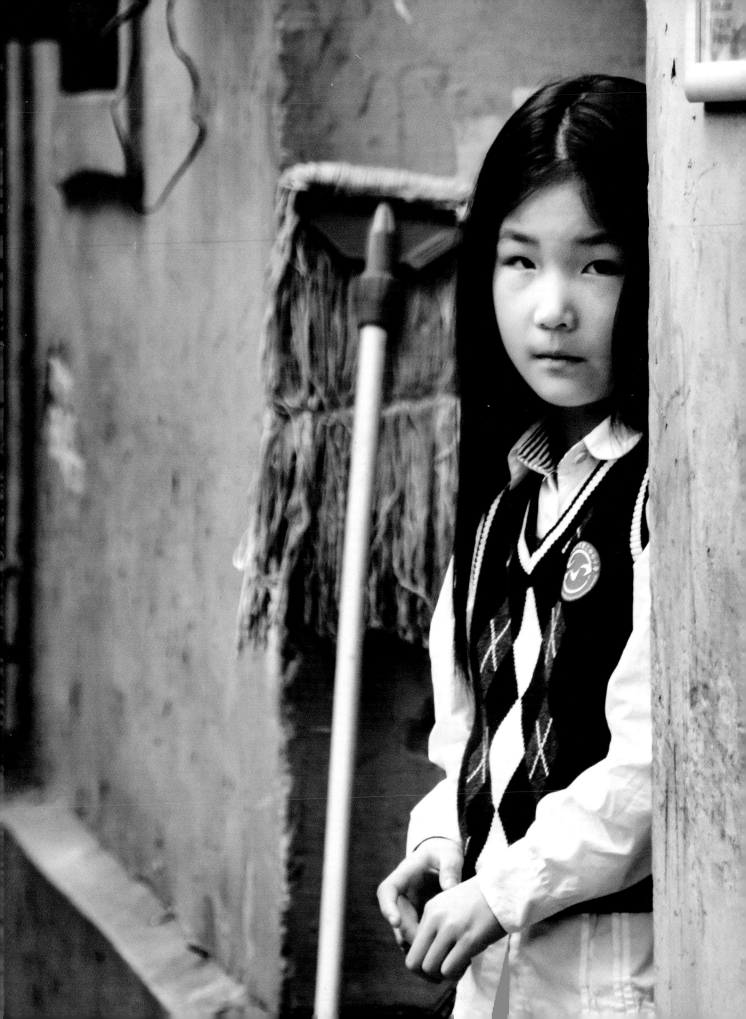

To know another is
not to know
a person's face but
that person's heart

Chinese proverb

知人知面不知心
中国谚语

We had so much help from **Faces We Love** who thankfully also have... **Beautiful Minds We Love**

Day 2 Day Heavy Lifters:

Lydia Delaney Editor & Everything Else
David Wilk & the Booktrix Dream Team
Zhuowei Amber Wang Book Development Coordinator & Super Mom
Natasha Rees Book Designer our London Lover of Cats
Joshua Schwartz, Ashley Durrer & Anna Miller our PubVendo Superheroes
Jayme Johnson of Worthy Marketing Group & Baseball Mom
Erik Christopher our ebook Designer & Digital Da Vinci

Photologists, Creatologists & Other Cool Stuff:

Aly Song
Ayumi Sato
Ben Stephens
Chaz Andresen
Josh Gaylean
Kristen Farmer
Pamela Wu
Robert Krolcyk
Sarah Bethune-Kelly
Shao Yifei

Behind the Scenes Creates the Scenes:

Ada Wang
Ann Sophie Klessner de Meester & Divorce
Ashell Chanda
Danny, Chuan Xiao & Fafa
Gen & Mei
Ida Mosbæk Gøllnitz
Jeremy Townsend
Joyce Herminia Vaz Brentjens
Nick & Tino Obolensky
2 wheels
Yaiza Mosbæk Gadegaard
humantouchmediafoundation.org

"Creative minds work
in unique ways"

Human Touch Media